HOW to Be SUPER CREATIVE

THE ARTIST'S GUIDE TO UNLEASHING YOUR IMAGINATION

CHRISTOPHER HART

Get Creative 6

Drawing with Christopher Hart
An imprint of **Get Creative 6**
19 West 21st Street, Suite 601
New York, NY 10010
Sixthandspringbooks.com

Editor
PAM KINGSLEY

Creative Director
IRENE LEDWITH

Chief Executive Officer
CAROLINE KILMER

President
ART JOINNIDES

Chairman
JAY STEIN

DEDICATION

*I'd like to thank everyone at
Soho Publishing for making this
book possible.*

*And thanks to my sister, Vicky,
for sharing historical facts about the
creative workings of Mozart's mind.*

CONTENTS

THE ROAD TO CREATIVITY

Artists are remarkable people. They feel what they see. They have no firewall to stop it. They are visual empaths with great imaginations. But the imagination is often unpredictable. You can hope to channel it when it smiles upon you, but hope is a bad strategy for creative types. You may sense an idea beginning to form when, suddenly, it's gone. Where did it go? This lack of control can be frustrating to artists.

I'll show you how to capture ideas before they drift away. This will allow you to see longer and more clearly—and be more creative. Transforming your imagination into a reliable tool and a fountain of ideas is what this book is all about.

Your imagination is like a kid whose teachers tell them, "You're not living up to your potential!" But the imagination isn't some unknowable thing, swirling above your head, close but just out of reach; it's a place where things are in a perpetual state of becoming.

As someone who has written over a hundred books, I have often been asked by my readers, "How do you come up with your ideas?" It's not really about "*how*" but "*where.*" The imagination has many rooms, with doors that are continually opening and closing. You need to get through them, so you can work the controls and push your creativity to new levels.

But most of them are locked. Newcomers keep pulling on the first doorknob, hoping to get inside. I will show you that if you turn your head, just slightly, you'll see dozens of doors lining the corridor. Let's try some of those, too.

Together, we can prod the imagination into giving up its secrets, and put you in the driver's seat. The first thing we have to do is stop being so grateful to the imagination for blessing us with its occasional visits. This time, we'll pay it a visit.

You and I are about to embark on a journey to the various corners of your imagination. We'll pull back the curtains on the gears and gizmos to see what ignites your creativity. We'll come away with a trunk full of new concepts, strategies, ideas, and techniques. This could be your most practical book of inspiration.

I keep one of these in my imagination, just in case.

ONE ARTIST'S JOURNEY

Each of us finds our own unique road to creativity. Once an artist discovers their path, many possibilities open up. Things you used to see in shades of gray are suddenly bursting with color. These are deeply personal adventures, but, as artists, we all share the same excitement at our moments of discovery. I thought I might begin by sharing mine with you, while at the same time giving you a glimpse into the worlds of art, writing, and publishing—how they sometimes tie together, and how you might find your place among them.

I entered the world with what should have been an advantage, in that my parents were both highly educated and placed great value on the arts—but that wasn't the case. Although my mother had a sweet disposition, she had her troubles, which she was never able to overcome. My father, who was a comedy writer, could be funny, even charming. But he also flew into frequent rages that terrified me.

Early in grade school, my sister and I shared a secret with each other: we wished we had a different father. I hatched many fantastical escape plans. My prayers for escape were answered, although not how I had anticipated. I found a few pencils scattered about the apartment and decided to draw.

The first drawing I remember doing was a busy scene

Many artists are inspired by a feeling. But a feeling, while important, can take you only so far. To create a concept, you'll have to engage your imagination.

of Robin Hood in the forest on an oversize piece of gray cardboard. I added more and more detail to it each night and silhouetted the main character. After a week or two, it was done. I can still picture it in my mind. I was proud of it. The imagination was, for me, not so much a *thing* but a *place*, and in this place I could use art to create happy feelings.

Animated cartoons were my port in the storm. Most weekends my sister and I sat in front of the TV from morning until noon, at which point she would go off to do something else. My sister was a good reader. Even though I was her older brother, I couldn't read. I wanted to. But whenever I attempted to read a book, the words swam all over the page, dynamically and in motion.

Instead of books, I poured over illustrated magazines and comic books, trying to tease out their meaning without the aid of the words. I kept this a secret. I don't know why. Kids are like that.

When I was in third grade, we were asked to draw a park scene. I drew a squirrel sitting on a stone ledge. I thought it came out well. The next day, a different teacher entered the classroom and asked me to follow her. We walked down the hall and several flights of stairs to a large room where the school's art instructor was waiting with another student, who I knew was a talented artist. I liked the art teacher very much. She had a kind smile. She said they had noticed my drawings and that, from then on, I would come to this classroom instead of the regular class.

> **The imagination was, for me, not so much a *thing* but a *place*, and in this place I could use art to create happy feelings.**

Then one day I came home to discover that we were moving. A few weeks before, a man had been slashed with a knife many times in front of our apartment. I saw it. He was crying for help. I can still hear it. And just like that, we were gone. And we kept moving, from Brooklyn clear across the country to California, from one hotel or rental to another, a total of seven places in four years. I lost everything—the school, the friends, and the relatives I loved. I didn't know it then, but, at the age of nine, my childhood was over.

My new school was unsafe. Many of the kids there proudly wielded pocketknives with long blades and were only too happy to open them up and show them off. I can't even remember how many times I was robbed at school, the point of a knife pushed into my back. If I resisted, they pushed harder. I couldn't believe I was in such a terrible place.

One saving grace was that there was a small movie theater tucked away on this school's campus. Every day at lunch, they played classic black-and-white movies like *Dr. Jekyll and Mr. Hyde*. This became my refuge and I enjoyed these movies immensely. I found

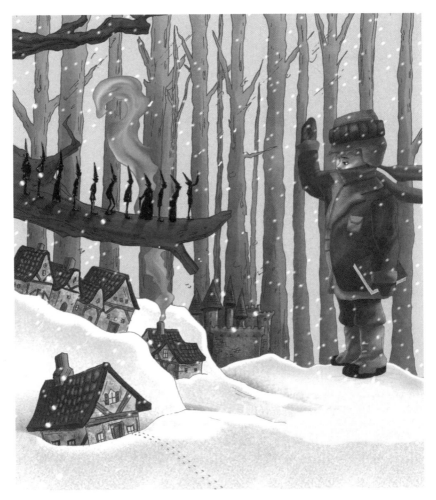

When I was a boy, I imagined many things. I could travel to faraway places without leaving my room. One snowy winter, I came upon some magical beings who lived there. They allowed me to visit if I promised not to reveal their whereabouts. It is an oath I have kept to this day.

the transformation from good to evil particularly compelling, and this provided me with insights that I would draw upon later in my character designs. Most importantly, it was dark. So dark that no one could see me. I felt safe, for ninety minutes.

Reruns of *Star Trek* also helped me keep my sanity. No matter where we lived or how awful things got, every night I could count on Captain Kirk to steer the *Enterprise* to safety. It resonated deeply with me, as it had, apparently, with a great many other young viewers. To me, it was not a show about science fiction, it was about personal sacrifice. The characters sacrificed

> **No matter where we lived or how awful things got, every night I could count on Captain Kirk to steer the *Enterprise* to safety.**

for one another—for the crew, for the ship, for the mission. These were astonishing lessons for me.

When I was eleven, my parents sent me to sleepaway camp. I hated marshmallows and sleeping bags, but I ended up liking it anyway. We hiked, swam—all the classic summer camp stuff. Most of the art sessions consisted of making lanyard keychains, but in one class the counselors taught kids how to draw cartons. I had drawn cartoons before, but this time it struck me that they held a direction for my artwork. My imagination was once again breathing life into my tired spirits. I left camp with a new mission and a brighter outlook: I wanted to be a cartoonist!

When I was thirteen, we moved to Beverly Hills. One of the kids I met in school there also drew cartoons. I asked my mother if we could get some art supplies at the little shop down the road. It was the first art store I had ever been in. The owner got a kick out of my enthusiasm. Once I got home, I drew for hours upon hours.

One night, I was working late on an art project. It was a character painting of a cartoon polar bear. It was also the best work I had ever done, and I knew it. My father had never offered a compliment on my art. But that night he looked over my shoulder to see what I was doing. I paused and looked up at him, hopeful. Saying nothing, he turned and walked away. But this time, his dismissiveness didn't hurt. I didn't need the acknowledgment. The little cartoon on my desk said it all. My imagination had my back.

In high school, I found myself assigned a seat in social studies next to that other cartoonist. We began showing each other the drawings we were working on. Together, we enrolled in a life drawing class at the Screen Cartoonists Guild in Hollywood, a professional union that allowed non-pros to take their classes. I had never taken a life drawing class before and wasn't entirely sure what the subject even meant. But we were quite a sight: a bunch of professional animators and two sixteen-year-olds sketching models week after week.

Still in high school, I showed my portfolio of original cartoon characters to the producer of a small animation studio in San Diego. The next thing I knew, I was driving three hours each way from Los Angeles to San Diego and back on weekends for my first professional job as a character designer. It was one of the happiest times of my life. I could leave the pressure cooker of home behind for at least two days a week.

It was around this time that I happened upon an out-of-print book about Disney. I bought it. Why? I don't know, as I couldn't read. But I had never tried nonfiction before and I discovered, to my great surprise, that I could. I later found that I had no trouble reading dialogue and screenplays. If the text was spare and really moved, I had no problem with it. But thick fictional narratives remained impossible for me. And to think of all the Shakespeare I missed out on in eighth grade!

After high school, I enrolled in California Institute of the Arts (CalArts), which had an extensive animation program with amazingly

talented students and accomplished instructors. However, I was more interested in the conceptual approaches of story, character design, and layout than animation, which I found tedious. So I left and enrolled in the Tisch School of Arts at New York University, where I focused on story development.

After graduation, I worked on staff as a writer for several prime-time television shows. I also wrote original screenplays for two different studios and an adaptation for a cable TV studio, as well as my own original screenplay. I got hired to do first drafts, rewrites, and polishes. I had many story sessions and lunches. But unlike the television shows I worked on, which aired, the screenplays did not get produced, even though I was paid to write them. This is not unusual in Hollywood.

Movies are very expensive to make. If an executive greenlights a movie and it bombs, it's many millions of dollars down the drain. People lose their jobs over decisions like that. It's safer to pass on a project, whereas TV eats up material because of its scheduled programming. Of course, another reason could be that my screenplays simply weren't what they wanted. Pick your reason—either way it was discouraging.

I was trying to figure out my way forward when I received an unexpected query from an editor at an art book publisher: Would I be interested in writing a book on how to draw cartoons? My background as a cartoonist must have been floating around in the ether.

The editor asked me to work up a page-by-page layout as a proposal for the book. This sounded like an animation storyboard to me, so I was able to put those skills to work, just for a different final format. The editor loved it, and I was eventually signed up.

That book ended up doing very well; soon I was signed up to write multiple books and my publisher was bringing them out as fast as I could draw and write them. Two of my first five titles sold over 200,000

copies each. The next two books sold over 100,000 copies each. The last title . . . well, you can't always knock them out of the park!

My approach to art instruction was different from other author-illustrators, and I intended it to be. Most how-to art books, I believed, had too much text that took itself too seriously and not enough illustrations. I wanted to show rather than tell the reader what to do. I switched the emphasis. I stuffed the book with visuals and cut as much text as I could.

> **I wanted to show rather than tell the reader what to do.**

I also noticed that although the examples in many books were on topic and to the point, they were also unnecessarily dry and unappealing. For example, they might show the idea of perspective with an illustration of a chair, when it would surely have been more interesting to show it with a throne. Same perspective. Better imagery.

I also structured my books like screenplays: concepts and techniques introduced in earlier chapters pay off in later chapters, like a reveal, which is always fun. For me, art instruction is the story of how you get from here to there, while picking up tips all along the way.

It was around this time that it occurred to me that I had been thinking of myself only as a television and film writer, but I now had half a dozen published books, and readers were telling me I was an author of illustrated books.

In creating art instruction books on many topics and genres, I was accessing different areas of my imagination in rapid succession: developing concepts, writing descriptive text, and illustrating characters. But none of these areas blended together. It was like riding a bike but switching gears constantly. It worked, but the ride was a little bumpy.

Every once in a while, I would get asked what I did for a living. I was never sure how to answer. An author? An artist? It began to dawn on me that everything I do is meant to express an idea. It doesn't matter how I get there. I am foremost a creative type who draws and writes. Maybe my skills don't blend. Maybe they're not supposed to. Each skill pops up as required—like an invisible toolbox orbiting my head!

My publisher approached me about doing a book on drawing anime. At that time, I didn't see much anime on American television and almost none in theaters. But the graphic novel section of bookstores was exploding with manga (Japanese cartoons). I thought it over and said I would do a book on manga, not anime. They agreed.

I envisioned a book with high-impact, dynamic visuals, with character types you just don't see in American comics. As they say, it was not your parent's art instruction book. It looked different. It was different. The year it was published, the head of marketing told me that it became the number-one best-selling art book in the United States. More books on manga followed and I was told that at one point I had the number-one, -two, and -three top-selling art books in the U.S. I was a featured story on the cover of *Publisher's Weekly*, the trade magazine for the publishing industry.

Part of using your imagination is being able to see things others might not see or stop to really notice.

Part of using your imagination is being able to see things others might not see or stop to really notice. If you can hit the Pause button on creative thoughts as they fly past, you can capture so many possibilities. I'll give you an example. One afternoon as I was drawing, I glanced at an anatomical etching and had an epiphany that resulted in one of my best-selling books, *Human Anatomy Made Amazingly Easy*. It hit me that the traditional diagrams found in anatomy books were unnecessarily complex. They typically show three layers of muscles:

surface, secondary, and tertiary. My take was to focus only on the muscles and contours you can see on the surface of the body. Unless the reader plans to do surgery, who cares what the muscles look like beneath the abdominal wall? My approach made the topic of anatomy accessible to the beginner artist.

For the last twelve years, I've been with my present publisher, a partnership that has allowed me to explore a variety of new areas, including figure drawing, poses, fashion illustration, adult coloring books, and anime. This last topic resulted in my book *The Master Guide to Drawing Anime*, which has sold nearly a half million copies, has frequently held the top-selling slot in art instruction books, and spawned a successful series of related books.

Every artist has a different goal. Yours might be personal enjoyment, or you might be considering a career in the arts. What any artistic aspiration requires is an imagination you can access, an imagination that's dependable, that can unlock and fire up your creativity. I know where to find my imagination; I have a key to the door. Perhaps you're not sure where your imagination is located, or if you even have a key. You do. I'll show you how to find it, and together we'll open up a world of ideas and creativity. It's all within reach. Let's begin!

GETTING INSPIRED

Every so often, I'll come across an article where someone attempts to shed light on the epiphenomenon of creativity by measuring differences between an artist and a non-artist. The results are *not* shocking: the artist is more creative.

That's often where the inquisitiveness stops. The imagination avoids scrutiny because it is shrouded in mystery; it's both magical and practical and therefore not well understood. We will go further, stepping through the door and into the inner workings, where the factory of inspiration is grinding out ideas as fast as it can.

WHAT IS THE IMAGINATION?

The imagination is like a boiler room where ideas are bouncing around at great velocities and slamming into each other at unusual angles. This produces new thoughts and concepts. It's so energetic in there that it fatigues most mortals. I don't know why, but artists love it in there.

It's tempting to think of the imagination as a metaphor, but it's a real place with a defined structure. Inside there are three domains. Each one is dependent on the other two: the Idea Department, the Editorial Department, and the Contracting Department. We will explore all of these in a way that will make them useful to you in the next chapter, Your Amazing Imagination. There are other essential elements, too, such as feelings, which support and even drive the imagination but are not part of it. That's also coming up.

Another popular misconception is that the imagination is similar to a dream. Not the same. Dreams have no inherent logic and therefore make for poor concepts, even if they seem brilliant upon waking. The imagination, on the other hand, is both free-form and focused at the same time, like a children's picture book in search of a third act. It never sleeps. Imagine how much more creative you could be if you had access to it anytime. Every person has a key to the door of their imagination. But sometimes people misplace their keys. If you can't find them, I'll lend you mine. In we go!

Every person has a key to the door of their imagination.

UNLOCKING YOUR IMAGINATION

Great, we're here. How long a person can stay in their imagination depends on how long they can keep their hands off the machinery. Pay attention and don't bump into the cerebral cortex.

As a beginning artist, or even a more experienced one, you may have looked at your favorite artist's work and thought, "I can't draw like that." I've got news for you: there was a time when *they* couldn't draw like that, either. When people get discouraged about their artistic abilities, it's usually not because they can't draw. It's because they think drawing is easy only to discover that it isn't. It's understandable: after all, drawing isn't physics. On the other hand, most physicists can't draw.

Now you know where your ideas come from!

The term "artist" does not necessarily connote a level of proficiency. You can be a beginner and still be an artist. In fact, it's hard to become a professional artist without having been a beginner. But can you know if you're an artist before others recognize that quality in you and in your work? I believe so. Let's compare two beginners who are both creative, like to paint, and have about the same level of proficiency.

Let's assume the first person paints something. She gets a good response from others and leaves the work at that. The second person paints a scene. She also gets a good response, yet she's not happy with it. She searches her mind to figure out what it is that is bothering her. This person, I would say, is an artist. There's a streak of creative

integrity running through her that she depends on and trusts. It's as important to her as the brushes and the palette in her hands.

A unique feature of an artist is the ability to see relationships between ideas and images that may appear unrelated, faraway, and at different points in time. An artist feels in no way bound by the proximity of their ideas. Concepts and notions, all these things that end up in a cohesive piece of work, may start out galaxies apart. Artists, perhaps like yourself, make improbable connections all the time. You may believe that other people do, too. They do not. I want you to value this almost unreasonable ability of yours and to develop it further. This is your strength. We can develop it together to make it more reliably accessible. This is your adventure. You will travel this road often as you create works of art, from sketches to finished pieces. The road won't always be clear but, with some guidance, you may be able to see farther, and more clearly, than you do today.

Drawing often begins with a piece of paper and two words: "What if?" What if I moved the two figures closer together? What if I moved them farther apart? What if I added a third figure? What if they faced in another direction? What if they were different heights? What if their poses mirrored each other?

The imagination loves friction. When nascent ideas start to flicker, they can ignite.

It's like rubbing two sticks together. The imagination loves friction. When nascent ideas start to flicker, they can ignite. Unfortunately, they can also cool off and disappear just as quickly. I will show you how to keep the fire alive and burning.

ARTISTS ARE DIFFERENT

Everyone has an imagination. For most people, it hovers in the background unnoticed. Every once in a while, a piece flies off, catches the attention of its owner, and then becomes an idea.

An artist's imagination is like an idea store. In that store there are many wonderful things, but most of the images are random and pop in and out of existence, like fireflies, and are therefore unusable. However, there is one shelf where ideas are always in flux. It's only available to artists. It's where everything is possible.

There's a room in my house that is wallpapered with abstract designs. If I stare at it for more than a few beats, faces begin to emerge. If I were to lay tracing paper over one of the images and draw only the relevant lines, you would see what I'm seeing: cartoons, animals, ghosts, angels. I used to do this in hotel elevators as a kid. If I focused with enough concentration, I could see almost anything. If I wanted to see faces, I could see faces. If I wanted to see trees, trees were there.

The wallpaper in my house is over a dozen years old and I can still find new faces in it. If I weren't an artist, this might be cause for concern, but I assure you that it's just my imagination doing calisthenics.

Here's what is actually happening: I'm forcing my imagination to focus deeper, to make connections that don't yet exist. Not all artists believe they can lean on their imagination with conviction. They see it as something precious in the sense that it has a fragility that needs to be respected. But we're not talking about any imagination. We're talking about *your* imagination. It's not a person. If it's napping, give it a nudge, wake it up! It doesn't hold resentments. In the pages that follow, I'll discuss ways to jostle the little prince into action when its daydreaming about something completely unrelated.

Consider what happens when you start a drawing. You have an idea. As you sketch, you adjust to keep it on track with the image in your mind. But that image doesn't exist in your mind. Or *anywhere*. You can't find it on an MRI. Your doctor can't look into your ear canal and say, "You're conceptualizing a figure drawing." Yet you see it with such clarity that it guides your hand as you bring it to life. Don't you think you're remarkable? I think you are. You've got to admit, it's a neat trick.

But doesn't everybody see things in their mind's eye? Not the way an artist does. For example, if two witnesses were describing a person to a police sketch artist, the noncreative witness might say something like:

"He had big cheekbones. And kind of a frown."

The artist's observations about the same suspect might go like this:

"He has big cheekbones. And he has a frown with the eyebrows pushed together."

Did you notice the difference? The noncreative witness describes the image in the past, because he's *remembering*. The creative type isn't remembering it, he's seeing it *in real time*. His imagination isn't a ledger, it's a video. He sees it as clearly as if he were looking out his window at people walking by. Notice, too, that the creative person doesn't just describe things, he describes things *about* things, like a frown that looks like a frown because the eyebrows crush together.

The noncreative person can't see what's missing from an image. If their memory is incomplete, they can't fill it in it. For the creative type, images have a gravitational pull. The image *wants* to become something. And so, it will.

This is intensely practical. Once, for a book I was working on, I had chosen to draw an unusual animal at an unusual angle. There was limited

reference material for this particular animal and none for the angle I had selected. I paused to look at the drawing. How was I going to draw this? There was a certain logic to the form that struck me. I could feel the volume as I began to draw. I can't tell you exactly how I drew it in a technical sense. To a noncreative person, the imagination is wispy and inconsistent. To the creative artist, it is solid, reliable, and true. Ask more of it.

In many noncreative professions, when someone comes upon a problem, they look for a solution where one choice will prove to be right, and the other wrong. In the creative arts, answers are not always so clear. Each solution opens the door to more possibilities, which then offer even more possibilities. For the artist, one avenue may *look* right and yet another may *feel* right. Which do you choose? Art is a continuity of moving parts, ever changing, ever evolving, and revising itself. So how can you know what to do? Just as you can write two different endings to the same story, or create different versions of a drawing, the answer isn't always solved so much as it is *revealed*. Sometimes you have a favorite, other times one way works better, even if you love it less.

There's a wonderful logic to the inner world of creativity, although you may not recognize it. What seems like a memory could actually be your imagination, finding a home for your ideas. Let's see how it works.

THE ARTIST'S RECALL

Have you ever taken a drive through the country when you had a vague feeling that a road up ahead might hold something interesting? And you thought, "Why not?" You've been lost before and always found your way back to civilization, so you veer off the main road, with your navigational system barking at you nonstop.

You drive past an old, dilapidated barn. Its condition makes it intriguing. The wooden slats are uneven. You can see sunlight shimmering between them. The windows are boarded up. A lonely weathervane on the roof appears to be the only thing in working order.

You may never draw that barn. It's interesting, but you can't stop to take it all in. You're almost late for a dinner with distant relatives. Unfortunately, you can still make it in time if you hurry.

Six months from now you're drawing a scene of a playground, which doesn't seem to have the nostalgic look it needs. Perhaps sunlight could be streaming through the surrounding treetops. You can see it in your mind. That flicker of gold. It's just what the scene needs. Where did you come up with that? You saw it at the barn in the country six months before.

At times like these, has it occurred to you that you possess more than a convenient memory, but rather a special ability? This sort of recall comes from a murky area in which seemingly unimportant memories are filed away. They fade but remain retrievable with an uncanny vividness. They can be summoned simply by recalling a feeling.

Has it occurred to you that you possess more than a convenient memory, but rather a special ability?

GIFTED VS. TALENTED

These two words are bandied about as if they are synonymous, but they're not. People with these attributes take very different paths and have different processes and approaches. Here's the basic difference: Gifted people receive inspiration in almost finished form. Talented people must sweat for it.

Mozart's sheet music still exists. In it, nothing has been crossed out. There are no false starts. His compositions flowed to the page in a state of perfection. The work of the artist-genius has an aura about it. It's as if Mozart plucked the notes from heaven, and only he knew where to look for them.

Mozart's handwritten composition has nothing crossed out, no revisions. It's hard to write a perfect minuet on the first try. Unless you're Mozart.

Both gifted people and talented people ride waves of inspiration. But gifted artists tend to allow inspiration free rein. That's why they may seem slightly disconnected from the work they're creating. But nothing could be further from the truth. They're completely connected. They trust the moment. They don't need to own it, they allow it to be.

When I was living in California, I was collaborating with a film director who had directed some of my favorite movies. A snippet of how he worked is illustrative of this point. He was a gifted storyteller,

and his ideas bubbled up as I scampered to keep pace. I remember telling him what I envisioned for a particular scene, when he stopped me, midsentence:

> DIRECTOR: *He's lying.*
>
> ME: *Who is?*
>
> DIRECTOR: *The character. Right there. He's lying.*

(Wow, what an interesting choice. It was a sudden turn of events, but he was right. The character should be lying. I was intrigued.)

> ME: *What is the character lying about?*
>
> DIRECTOR: *I don't know. You're the writer.*

He hadn't been figuring it out; he was watching the story unfold, and he stopped me when he felt I had deviated from its natural trajectory. Not everything that a gifted person creates is perfect from the start. Things need to be tweaked, shortened, lengthened, and revised. But when it's right, it often comes gift wrapped with a little bow on top.

What about the talented person? This person gets a flicker of an idea, a notion, a concept, or an epiphany. (The terms "idea" and "concept" are often used interchangeably in everyday speech. But there's a nuanced difference between them, which is helpful in developing a creative project. An idea is simple. A concept is an idea with scaffolding.) But it's incomplete, and then it's gone. These sparks have places to go, things to do, people to see, but they leave behind promising embers. The talented person reconstructs them into a workable whole. There isn't the same ease as there is for the gifted person.

On the other hand, talent tends to travel better. Talent can be applied to different areas within the arts—and by the same person. You can see it in the hyphenates, like writer-illustrator, writer-director, singer-songwriter.

"WHAT IF I'M NOT SURE I HAVE TALENT?"

This is a common concern, but the question has a fatal flaw. The person asking the question usually already has talent. In my experience, artists at all levels possess ample talent. It may be hard to recognize because you believe your talent lies in one area when you're more talented in another. That's very common, and it has thwarted the careers of many aspiring artists who should be well known. It wasn't a case of whether they had talent, but which talent they had. Talent doesn't care if you like the ability it chose for you. You don't have to take orders from your talent, but when you work together, sparks fly.

Let me offer a personal example. Before I began my career as an author, I never thought about doing a book; it was the result of a series of events that almost didn't happen. Months after I handed in my first book, the publisher called me to review the pages in progress. I had never done this before, so I didn't know what was expected of me. The production manager, senior editor, and book designer were all present. They wanted my comments. I didn't want it to appear that I knew as little as I did, so I planned to remain quiet through the whole meeting.

They began flipping through the pages, one after another. They made comments, which sounded right, and I nodded along. Suddenly, I said the left page looked skimpy. There were too few images, but if we bumped up the size of the images on the right page, we could steal one of those and put it on the left page, so they would both look full.

They all looked at each other. No one said a word. I thought I may have said something wrong. It felt like ten minutes of silence. The production manager then said, "We can do that," and went to the next page.

After a few more pages, I interjected again. I said the emphasis should be reversed on a certain layout. They agreed and made notes. They started looking to me for input. On it went, just like that, with me yammering away until the end of the book.

I left the meeting happy but puzzled. I didn't know how I had the instincts I did. They knew much more about book design. Yet something happened in that meeting. It was *easy* for me to figure out how to solve the pages. It was obvious. But why was it obvious?

Much later I realized that if others struggle to do something that comes easily to you, bells should go off. Consider: maybe it isn't so easy. Maybe it's you. Maybe you simply *know*. The trick is to know you know.

> **If others struggle to do something that comes easily to you, bells should go off. Consider: maybe it isn't so easy. Maybe you simply *know*. The trick is to know you know.**

Let's bring this back to the present and apply it to you. Let's suppose you've been commissioned to create a mural. You're going to transform a wall in a trendy clothing store into a café scene in Italy. Not your specialty, but this is money and a credit. You finish it, and you see that a local newspaper and some other media are doing a piece on it, raising your profile.

At this point, the average artist probably thinks something along these lines: "Why doesn't anybody cover my specialty, landscape painting?"

Here's what I want you to think instead: "Maybe I'll paint a café in Paris next."

Let's say this artist has painted landscapes for years. Never once has a newspaper done a story on his work. He paints a mural one time and suddenly the media is interviewing him. What the heck is that about? Sometimes your talent doesn't like what you've chosen, and you wonder why you're not making progress. It's a team effort. You guys have to work together.

Sometimes, talent is the thing you become known for, even if you love something else more. Babe Ruth began his career as a pitcher, and he was a very good pitcher. It was then discovered that he was a monster hitter.

> **Sometimes, talent is the thing you become known for, even if you love something else more If your talent is trying to get your attention, you might want to listen.**

So he stopped pitching. Maybe he liked pitching more. We'll never know. I don't recall him complaining about it much. It's like that with talent. No one can or should advise you not to follow your heart, but if your talent is trying to get your attention, you might want to listen.

KNOW WHICH TEAM YOU ARE ON

Art generally falls into two broad categories. The first focuses on things that look real, such as a landscape, still life, and the human form. This is "representative art." An extreme example is photorealism. Many artists in this area do painting, figure drawing, concept art, and sculpting.

If you draw horseback riders that end up looking like this guy, that says something about the type of artist you are.

The second type is "interpretive art." The subject serves as a spring-board to create stylized and imaginative images. This style is found in commercial art, animation, manga, children's book illustration, and abstract art, to name a few.

These are fluid categories; artists often go back and forth between them. Usually, an artist favors one approach over another. A problem arises when an artist whose work clearly belongs in one category prefers to work in the other. There's no law that says you must work like this and not like that. However, if your still-life illustrations look cartoony, you might want to consider a genre where your art is a better fit, like animation. There is every possibility that your art could take you farther and to greater heights if the subjects you focus on are part of who you are as an artist rather than what you're a fan of.

Fighting your creative instincts is a tough battle. For example, let's say you like to draw knights. You've drawn them since you were a teenager. You try widening your portfolio by drawing horses but every time you do, you finish them with knights riding on them and a castle in the background. Before you get frustrated with yourself, you should know there is a term for this: it's called "fantasy art" and the genre has plenty of fans. Some people don't like to draw what they're particularly good at because it's easy. This idea is so wrong, there isn't even a term for it! Let's get you back into the I-respect-my-own-abilities business.

Most artists try to bring their ideas to their drawing. I want you to find the subjects that give you the ideas. Be open to inspiration. See what clicks and toss out anything that doesn't. The imagination has a funny way of tapping artists on the shoulder. Let's find out what it has in store for you. We are about to enter the engine room.

YOUR AMAZING IMAGINATION

Your imagination has been a part of you from the moment you were born. No doubt you've enjoyed having one. But what exactly is it?

What is this fickle, unpredictable, and inspiring spirit mechanism that artists have come to love and scorn? Why won't it do what you want it to do when you need it to? Why does it perform, but only sometimes? This turbulent relationship is at the heart of all artistic endeavors.

You can't see the imagination, but everybody has one. Visual artists and writers seem to have ones with all the bells and whistles. Your imagination has three distinct levels, which make it hum.

The Idea Department: This is the first level of your imagination and it percolates with concepts and fragments of concepts. In the Idea Department things are not seen as they are but as they could be. Everything evolves into something else, which then evolves into something further. Because it's dreamy, it tends to wander. It needs direction. You also need to know when to put the brakes on a good idea before it changes so much that it loses its original spark.

The Editorial Department: The second level is an essential part of a well-run imagination. When your mind is in editing mode, it neither likes nor dislikes your art, it simply makes the call as to whether an idea works. Without it, you would love everything you did, to your detriment. Fortunately, we all have one of these, but unfortunately we don't always make sufficient use of it.

The Contracting Department: The last level of your imagination gathers material from the first two departments and pulls it together in a way that is pleasing to both the viewer and the artist. Develop this department. It can become one of your greatest assets.

Your imagination comes with great gifts, but it's imperfect. These departments don't always like to play together. You need to create a working collaboration. Your imagination needs you as much as you need it.

FEELINGS AND CREATIVITY

In life drawing classes, instructors often focus on their students' ideas, concepts, and perceptions, but not their feelings. An instructor may suggest that a student see something a different way, but they won't suggest that a student feel something different than they do. That's because feelings are hard to direct. You need ideas for that, which is the province of the imagination. Feelings are emotional impressions that need to be converted into visual form by the imagination in order to be communicated effectively.

Feelings and the imagination are like runners in a relay race handing off the baton to each other. You can go only so far with a feeling before you need more clarity, which is when it's time to bring in the imagination. The imagination loves to veer off course (it's such a curious thing), so pause every so often to check if your initial feeling still matches what you're drawing. If they are no longer in sync, you have the option of adjusting your feelings to match the new direction, or you could put your drawing back on its original path. But it's not a great idea to continue deviating from your original idea with a feeling that no longer serves as your compass. Don't allow your inner world to be at cross purposes.

Back and forth you go, checking, adjusting, checking, adjusting. It's like a creative bicycle. Feelings and the imagination may never have coffee together, but when it comes to creating art, they're a great team.

LET'S GO IN FOR A CLOSER LOOK

The imagination is a cloud of images going in and out of focus. Even if you come upon one that's stable, it begins to evaporate before you can get a good look at it and develop it. Artists accept the imagination as it is because they have never truly pushed it. The imagination is a creative engine, but it's also more than that—it can be guided in the direction of your choice, making it much more productive and exciting.

You either have to find a way to get your imagination to stay still (good luck!) or find a way to get a closer look at your ideas. The longer you can visualize an image, the more you can do with it. An artist who sees something in his mind for ten seconds will draw it better than an artist who sees it for three. If you can hold an image in your mind, in that creative sweet spot, you can draw directly from it. You may believe that once a mental image has sailed over the creative horizon, it's gone and out of sight. Let's be brash. Let's pretend we're wrong about that. We're not going to let go so easily next time. We're going to hold on to that image for another five seconds. Or two seconds. It takes focused effort, but if you're determined and persistent, you can hold it in place a little longer. It may be all you need to seize a concept or visualize the contours of an image from some other time or place. You're like a kid in a movie theater. When the lights go off, you can't see. But when your eyes adjust, everything is still there.

You may ask, "Isn't art supposed to flow without effort?" I'm not talking about art. I'm talking about ideas. Later they'll become art, but even things that flow take some effort.

VISUALIZE THIS

The ability to recall something you've seen in order to draw it is part of every artist's skill set. Without it, we simply could not draw. Visualizing brings things into focus. We all have this ability to one extent or another. It's such a natural skill for artists that we rarely consider developing it further. Let's try anyway.

An average person thinks visual thoughts in generalities. For example, they might recall seeing a funny-looking person at a bodega pay for a smoothie while carrying a small dog in a tote bag. Everything about the picture is vague. This type of minimally defined recall isn't terribly useful to artists who want to remember a scene in order to draw it. Some artists therefore re-create the scene leaving out all the quirky stuff that made it interesting. There's a better option.

You may not be aware of it, but there's a small closet in the back of your imagination for gadgets. On the top shelf there's a special zoom lens. Grab it. I want you to aim it at what you want to draw and focus on what it is you see.

Going back to the example, let's focus on the cashier. What did he look like? You don't remember? Let's zoom in. There he is. Is he in profile or in a three-quarter profile? He's in profile. Is he wearing glasses? He's wearing them. What do they look like? They're kind of square shaped. Is he taller or shorter than

As artists, we often look to create an entire scene around a single point of focus. That's a good approach, but you can also create smaller points of focus throughout a picture, like the ones in this simple illustration.

the customer? He's shorter. What's that, in the background? Let's zoom in again. It's wallpaper. Where did the customer enter? Can't quite see that. Zoom out. There's a door to the right.

If you practice recalling things granularly, even if you don't proceed immediately to a drawing, you may find that eventually you won't need to carry around a sketchbook all the time. You can also visualize things

based solely on feelings. For example, one night, when my kids were young, we were watching TV together. I was sketching away. My younger daughter, who was too far from me to see what I was drawing, said, "Hey, Dad, are you drawing a mischievous guy?" Surprised, I said, "Yes, how'd you know?" She said, "Your face."

I like to feel an expression as I'm drawing it.

SETTING UP SHOP

This is not one of those books where the author recommends his favorite art supplies, but if I'm not talking about that, just what do I mean by "setting up shop?"

The imagination needs a familiar place to do its work. A place where the gears engage. Often, it's a drafting table. But you may have better luck coming up with ideas elsewhere. I often get my best ideas when I'm at a crushingly boring event. My imagination can't stand it and will begin doing acrobatics in order to keep my spirit alive. Here are a few places that have helped me. Go to a lecture. About anything. Wait in a doctor's office. Listen to a commencement speech. Browse the soldering irons at a hardware store. Your imagination will be begging for mercy. Be sure to bring a pad and pencil with you!

Your imagination is a location, every bit as real as your home or elsewhere. Let's develop that further. It's where good things happen. There's a feeling of excitement. You can make it anything you want it to be. Physical limitations hold no sway over the dimensions.

You may not have thought of your imagination as a workspace you can customize visually. To give you an idea of what I'm describing, I'll tell you what mine looks like. It's set up as a home media center. I always

wanted one of those, but the one in my imagination is much less expensive, easy to install, and you won't be asked to fill out a survey afterward. In this media center, there's a large overhead slideshow setup. This is where I go when I'm trying to solve a visual problem. I'll bring up an image, like a character, and I'll see it in my mind. If it doesn't work, I'll click to the next slide. (Best of all, I never have to worry about losing the remote control under a seat cushion.)

If I like something I see, I'll slow down and try to modify parts of the image mentally, refining it, coaxing it into being. If it's not perfect on the first try (and it never is), I click to the next slide. With each successive slide, I go a little deeper and take more chances. Over and over, I do this until an image takes on a sense of inevitability and becomes something I can use.

Even if I don't solve the visual riddle, I will have explored and eliminated a number of avenues. As a result, I am looking in fewer directions and homing in on a solution.

Now let's turn to *your* imagination studio. You can create any environment and change it as many times as you'd like. It could be several compartments, one for general ideas, one for revisions, and one for details. Or something more literal, like a replica of an art studio where you once took drawing lessons. You don't have to keep it fixed in your mind while you create. Perhaps it's just a welcoming image, a doormat in front of a friendly place—whatever makes you feel comfortable enough to let the inspiration flow.

So, what would you like your studio look like?

YOU DON'T NEED TO BE READY

You don't have to wait for an idea to be fully formed in order to get started. Giving the imagination a few nudges in the right direction can help a concept develop and gain traction. It breaks the inertia.

Let's give it a try together, to coax the imagination along, step-by-step, extending an idea until we hit on something inspired. Here goes!

What are you thinking about?

A restaurant.

Good. What time of day is it?

A restaurant at the end of the day.

Anything out of the ordinary going on there?

A restaurant at the end of the day, as a family business closes for good.

There's some traction! Let's counterbalance it with something positive but poignant.

A restaurant at the end of the day, as a family business closes for good, and the owner shakes a customer's hand.

The above scenario came courtesy of the Idea Department. Now let's bring in the Editorial Department. How does that work, exactly? It's not going to help you to come up with ideas. That's not its job. It is exquisitely sensitive at detecting when you're going off track so you can be more effective. Sometimes your Editorial Department will want you to change what you're drawing or writing. When that happens, it generally means that you've fallen in love with an approach that doesn't work for your overall goal, in which case you may have to recalibrate. The Editorial Department doesn't like anything or dislike anything. Its sole mission is to give you perspective. This can be frustrating to artists who pine for compliments and encouragement. You're not going to get them from Editorial. Listen to its comments anyway. After all, you created them—literally. This is an essential tool. Without it, your work will lose its focus.

There's another role of the Editorial Department: there are artists at all levels who cannot distinguish their superior work from their average

work. This is common and understandable. It's hard to be a neutral observer of your own work when you have so much emotionally invested in it. The Editorial Department can give you that guidance—if you don't try to elicit the answer you're looking for. When dealing with the Editorial Department, don't place your finger on the scale.

How about the Contracting Department? What role does it play in that creative brain of yours? It glues the different parts of an idea together once everything has been decided. When you're ready to finish a drawing, you generally have two concepts in mind: the first is your original, rough idea, and the second is the finished drawing you want it to become.

Let's say that your ideas for revising the original, which made perfect sense in the abstract, don't work as envisioned. You discover problems. Further, the original drawing appears to be pretty good in places you were planning to cut!

You could either proceed with the changes you had intended to make, which you no longer completely believe in, or go back to the original drawing, which retains that spark of liveliness, but with flaws. While either is fine, a third approach may be more likely to give you the result you want. This isn't about repairing your work but rather taking an additional step in the creative process. It goes like this:

1. Create a rough drawing.
2. Identify problems.
3. Revise with creative solutions, rather than merely cleaning up the original sketch.

It's the job of the Contracting Department to bring your art from rough to finished. It connects the dots. For example, let's turn back to the picture of the family restaurant that's closing. Suppose you wanted to make it clearer to the viewer what is going on. How would you solve that? One practical solution might be to show the restaurant

owner locking the door on his way out, but then you would lose that meaningful handshake with the customer. Or maybe the owner wipes away a tear, but that takes the scene from poignant to maudlin. Let's reach further for something creative, maybe even a solution outside of the drawing itself. How about titling the painting, "A Restaurant Closes in Brooklyn." We add the words, "in Brooklyn" because if it closes in Brooklyn, it's not just closing for the night, it's closing for forever. Now you don't need to change the drawing at all. In fact, this solution doesn't "fix" anything. It's a creative addition.

IT'S A TEAM EFFORT

How do these different departments of the imagination work together in practice? Let's say that the Idea Department sends you an image to draw of a pair of eyes, which you do. Suddenly, you get a message from the Editorial Department, which has noticed that the left eye looks better than the right eye. So you fix the right eye . . . but you do such a good job fixing the right eye that the left eye no longer looks as good. So you make a few improvements to the left one, which now looks better than the right one, which is where you began. You could do this forever.

Frustrated, you take a quick gaze out the window. Windows are irresistible to the imagination. Almost immediately, the Idea Department starts to percolate. You try . . . something. You draw an eyebrow close to one of the eyes, leaving the other eyebrow arched. The uneven eyes now look right, even though you haven't touched them, because eyebrows exert pressure on the eyes, which change shape based on how close the eyebrows are to them. Therefore, there's no longer a need for symmetry, in fact, it looks more interesting without it. It's time to bring in the Contracting Department to pull all the elements together and finish the drawing.

So, what just happened in solving the "eyes" drawing? Your imagination automatically transferred your project from one

department to another, seamlessly. You went from Ideas to Editorial, to Contracting in two minutes. Many artists remain in the Idea Department too long, drawing the same eyes over and over again, looking for perfection instead of a solution. The more aware you become of this process, the more effectively you'll be able to shift to where the help is. Many beginning artists often give up on a drawing before they've taken a good look at it. If they had shifted to the Editorial mindset, they might have opened up more possibilities.

Like any muscle you exercise too often, an artist's imagination can become fatigued. Every once in a while, you may feel the need to hit the Pause button. This doesn't mean you should stop being creative. It means you should stop solving creative problems. In other words, allow your daydreams to float by with no purpose or direction. If you're at a coffee shop, take note of a bystander and leave it at that. Remember what you did yesterday. Think about something you'd like to do. Imagine it, but don't plan it. Chase after your ideas tomorrow and give yourself a creative rest.

Creativity is a force that exerts a pull. Soon, whatever you're dreaming about will seize your attention, whether you want it to or not, and in you go. The famous last words of every creative person are, "Go without me. I'll catch up. I'm just jotting down an idea."

Creativity is a force that exerts a pull.

The paths you clear to find your special place will remain open to you forever. Once you know how to get there, you will remember the way. Are you ready to go? We're about to take the deepest dive in.

ENTER THE ZONE

Every once in a while, something curious happens to artists, writers, and other creative people. It may have happened to you. An idea escapes the confines of the imagination and finds its way into the real world. Most

of the time, these idea-lings return and nobody is the wiser, but on rare occasions, they forget their way back. And they land. On your pencil.

You're at the drawing table or writing at your computer when a vague feeling comes over you. You're not struggling to put down words or images. Creatively, things seem to be going your way. Solutions to sticking points become obvious. Drawings appear better than you imagined them. It's as if your artwork is unfolding before your eyes of its own accord. You can do no wrong. You could almost let go of the pencil and it would keep drawing.

For a brief few moments, all things are possible and greater abilities than you possess guide your efforts. You wish you could trap lightning in a bottle. Careful. This is where people blow it. Once they realize what's happening, that they're in the *zone*, they want to enjoy the moment. Possess it. Or they pause to admire their work. If you do either, the moment will be over. This moment isn't yours. I know it sounds odd, but it isn't. You were lucky to be given a ticket to the show but stay in your seat. This isn't happening *to you*. It's happening *in front of you*. Stay in your lane. Don't judge it. Don't editorialize. Don't force it to take a different direction. You can do all of those things once it's over. It needs a pencil. You've got a pencil. Just draw.

I'm not saying you're a vessel. You're more like a witness to a garden that's blooming wildly while you're standing in the middle with a watering can. This is not the time to prune. Eventually the can will be empty, and you'll have plenty of work to do.

As everything falls into place, and that may happen quickly, your eyes dart from paper to pencil and back again. You feel an urgency to keep up. Don't pause. You have very little time. When the moment begins to fade, there will be an afterglow trailing off. Stay with it.

And it's gone.

Did you capture it? You did. The embers are still smoldering. It's all there and yet it may not be right. That's not a contradiction. After all, your stream of inspiration wasn't paying attention to your outline. It followed its own wonderful path. Now that it's over, your artwork needs your judgment to bring it safely into harbor.

You're back now. You may be a little disappointed. Try not to be. Be grateful. You may wonder how you can find this special place again. You can't. It will find you.

Sometimes it's subtle, so you may not notice that your concentration hit an unusual crescendo. When you review your work—in a day, in a year—you may wonder how a few simple lines translated so elegantly to the page.

NOW WHAT?

Now you need to finish the drawing, which is still just a sketch. If you tinker with it and don't get it right, you could ruin it and begin baying at the moon. Believe me, neighbors hate baying. Therefore, draw on an overlay to try out any changes. Programs for drawing on a tablet may have similar options.

As you clean up the rough, you might shy away from trying out new ideas because you don't want to ruin the piece you drew so well while you were in the Zone. One of the most emotionally difficult tasks for an artist is to change something you love because it needs to be changed. Make the changes. This is no longer your original piece, and you're not in the exact same mindset as when you drew it. Creating art has a temporal quality. When you created it, you may have loved it as a 10 on a scale of 1 to 10. Two hours later, you love it an 8. Another two hours, maybe a 7. Which feeling should you listen to? The one right now. Always, right now.

But save your sketch before making changes by scanning it or copying it or just tracing the changes over it. That way, you can make bold

choices without worrying that you've adulterated the original. That's creative freedom.

There is another aspect, too, which you may want to consider. Sometimes a drawing starts off perfectly, and it becomes the foundation for the rest of the image.

But as you continue to draw, you keep glancing at the way you started. You notice there's something not quite right about it. But you don't dare touch it because it's the basis for everything that followed. It's good the way it is, you reason. This is what I call "the imperfect-perfect."

The deeper into the drawing you go, the more obvious the errors become. It's like drawing a wonderfully detailed image of a human figure, except the proportions are slightly off. You could add as much shading as you want but there's no way to fix something foundational with a few tweaks. What does a professional artist do in that situation? He whimpers at his realization, and reworks it. The difference between a beginning artist and a pro is that the pro is quicker to take the off-ramp when he finds he's driving in the wrong direction.

SOMETIMES IT WHISPERS

An epiphany is a great thing, but you can't live in the sublime. Let's not get greedy. Most of the time, art is immensely rewarding but it's also work. There are things to shade, planes to define, expressions to create, and anatomy to consider. But every once in a while, something out of the ordinary may occur to you. And you may experience it as a whisper, which you could overlook if you're not attuned to it. This whisper often comes from the Editorial side of your imagination.

Most of the time, art is immensely rewarding but it's also work.

Let's say you painted a lake in a country scene: it glistens with light dancing upon rippling water. You're proud of it. Nonetheless, the scene has been giving you trouble. You're about to take another crack at it when, out of nowhere, a quiet, almost imperceptible thought sweeps past: "It would be better without the lake." What? Wrong. Clearly wrong. The lake is the centerpiece. The lake is it. There's no picture without the lake. What a dumb idea.

Hold on: that thought came from you. It's *your* idea, and maybe not so dumb. So think about it. Just consider it.

Thoughts like this can be bothersome, even disturbing, which is why many artists dismiss them out of hand. Putting all practical considerations aside, ask yourself: "Would it work, though?" Tunnel vision can be an asset when everything is going your way—not so much when you're struggling.

Back to our painting of a lake. Look at the trees in the foreground, the ones that took you all of three minutes to paint. No matter what you've tried, they overshadow the lake. But if you made the trees the centerpiece of the scene, you could get rid of the lake that's been torturing you and the majesty of the trees would make sense.

Should you listen to your gut instincts or side with your investment in time and effort? Your Editorial Department doesn't care how much effort you've invested. It's not interested in figuring out how to save what you've already drawn or whether you'll have time to make it to the gym. It only wants your drawing to be great. And you're thinking about ignoring it? Whose side are you on? It gets even more counterintuitive: the more damaging your instincts are to the work at hand, the more important it is that you listen to them.

WHEN INSPIRATION TAKES A VACATION

There are times when you can't locate your imagination. You look under the bed, check your closet. Nothing. It's on vacation. But what if

you're in the middle of a project when your imagination fails to show up? You still have to move forward, inspired or not, but how?

It's time to bring in the Editorial Department again. A curious choice, right? Editors don't usually create ideas. They make decisions, suggestions, observations, and offer solutions on how to trim or expand things. So how do we approach this situation? We're going to trick the Editorial Department into switching roles. By coming up with well-crafted questions, the Editorial Department will produce useful answers that can keep your project going until your imagination emerges from a cabana. What could you ask yourself that might elicit the needed material?

Let's suppose that you're drawing animation-style characters. Questions could include:

What age range is this for?

Are we talking round or angular?

What's the character's personality?

Is this a two-second image (meaning the viewer gets it immediately) or something to sink into?

Should I use my personal style or an established genre?

What's the one thing in this picture that should stand out?

Should the environment/background be stylized?

Sharpening your questions leads to answers you can use. You can do this anytime you need some direction: your Editorial Department will be happy to oblige. Just don't ask for a new idea. That's like asking a genie for more wishes. It's just not done.

DOWN THE RABBIT HOLE

Artists are a determined bunch. It's their strength and—sometimes—
their weakness. They search for answers when no options are
apparent. A drawing may require small revisions or extensive ones.
They're willing to put in the work. It's an admirable quality, but that's
not the type of determination I'm talking about.

I'm talking about a different kind of persistence that every artist is
vulnerable to. At some point, an artist will continue to touch up or
revise a drawing so many times that they end up way off target. If
you're an experienced artist, you know what I mean. Oh, the agony.

It starts out innocuously. You've done a complex drawing and you feel
good about it. Everything about the drawing works. Except for one
small area. You make the change. Done! On second thought, there's
a part next to it that also needs a little adjustment. You fix that, too.
What about over there, next to the margin?

Let the games begin.

These selective improvements begin to migrate across the entire page.
This continues for hours as ruination descends on the poor piece of
paper. The irony is that a drawing that warrants so many changes
was never working in the first place and therefore may not be worth
so many revisions. This is different from a good drawing that needs
work. Such a drawing will be able to sustain a number of changes and
maintain its integrity. But with a drawing in the rabbit hole, every
change reveals another problem so that it becomes hard to tell where
the original stops and the alterations begin.

I'd like to shorten your stay at the Anxiety B&B, so here's a working
definition. If your artwork feels redolent of the items on the following
list, set a time limit for yourself. If a near-perfect drawing can't be fixed
within two hours, it's probably not near perfect and never will be.

Here's a checklist for recognizing a drawing with problems:

- The best part of the picture keeps needing changes. (If the best part doesn't work, what have you got?)
- Effort, not creativity, propels you forward.
- Everything about the drawing seems nearly perfect, but you can't close the gap.
- Calendar pages fly past and you're still fixing it.
- Every time you repair a problem, you see more that's wrong with it.
- When a revision doesn't work, and you put it back the way it was originally, it looks bad that way, too.
- You forget what you even liked about the picture.

Even if you find yourself nodding affirmatively to all of these points, it's still possible you could rescue an evil work-in-progress. (Make sure you write to me and let me know how.) Never underestimate the power of the creative mind. But sometimes cutting your losses is an even better strategy. And no one has to know that the first way didn't work. By freeing yourself up to think new thoughts and feel new feelings, you may find a better idea sitting on your shoulder. But first, you have to pause long enough to look up and see it.

CAN YOUR IMAGINATION STEER YOU WRONG?

Oddly enough, it can. For example, you might want to develop an idea for a neighborhood in a children's picture book. Concepts for neighborhoods pop into your brain, but then subtly begin to wander away. It's like getting on an elevator with the intention of getting off at the third floor but ending up on the eleventh because you didn't want to interrupt the flow.

A more devious trick of the imagination takes place when you've been working on a project that's no longer fun. It's been a slog when, suddenly, a new and appealing idea pops into your mind. No rough patches to fix. It's perfect!

Naturally, it occurs to you that maybe you should switch ideas, not realizing that eventually, every idea slows and needs work. Therefore, if you were to swap your current project for a new one, you would end up in the same spot!

A new idea is always more interesting than what you've been working on. However, the new idea will be an old idea in a few weeks, so it's important to keep perspective and not leap at the first shiny thing. You can always jump ship if you choose to but pause first. Your imagination is like an adorable puppy: it'll take over the house if you let it.

DEVELOPING YOUR IDEAS

"Boy meets girl" is a good idea, but an idea isn't enough. It's what you do with it that counts. It's in the execution of an idea that you find out what you've got. In 1955, Walt Disney did a boy-meets-girl film with a twist about two dogs from different sides of the tracks who fall in love. It resulted in what is, in my estimation, the greatest animated film of all time, *Lady and the Tramp*.

Every idea needs to be developed. Many premises that sound great don't survive scrutiny under the logic of storytelling. The weakness of a story usually reveals itself in the second act. The first act is easy—that's just setting up the idea when the viewer is most patient. The third act is also easy because that's the payoff, which is based on the premise. It's the second act that tests the concept and the audience or reader. Ideas are most in danger of running out of momentum here. Characters need to be developed, relationships must take unexpected turns, second agendas must be revealed, and the viewer's attachment to various characters must be strengthened, or broken.

Every idea runs the gauntlet of colliding concepts and considerations, some that work, some that don't, some that kill it, and others that save it. By working out a concept, you're building a grid around it, which will sustain it.

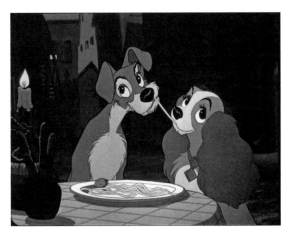

The simple concept of "boy meets girl" reconceived, which went on to become one of the best-loved animated movies of all time, **Lady and the Tramp.** © 1955 Disney

Sometimes you may find something that reinvigorates your enthusiasm for a project, like a side character. Maybe it's an entertaining sidekick, with funny dialogue or expressions and situations. You can come up with jokes all day for this character. He's much more interesting than solving your story problem, so you insert him into as many scenes as you can, even the ones that are already working. But a story is about relationships and things that happen. It's not a standup routine. Everything is about something. If the new character doesn't move the story forward, why is he there?

BEWARE THE GREAT IDEA

Sooner or later, an idea will hit you that you believe is not just a good idea, it's a Great Idea. An idea, you'll be convinced, that someone else will do if you don't do to it first. Okay, but let's tread a little cautiously. After all, if you're going to fall in love, it's important to be sure it's the right one. You might think a great idea comes together effortlessly, as if it were meant to be. It rarely works that way. Every idea has to be worked out.

We love our great ideas because of their novelty. You may need to create variations on the theme so the premise remains fresh, but ultimately, it's the characters and their through lines that will make your idea succeed. People don't remember concepts. They remember characters and situations.

The problem with many great ideas is: what happens next? If you don't develop it, it's just a premise. On the other hand, if you develop it too much, you could stray from your premise or overcomplicate it. This is the pull and tug of character and story development. It's a balancing act. If it's difficult, you know you're doing it right.

Let's walk through an example. Try this for an amusing little idea. Because of an error made by a rookie financial planner, a married couple inadvertently signs over the rights to all of their assets, including their bank account and house, to their ten-year-old son. The son likes the new arrangement and balks at returning the assets to his parents.

This is a classic "cute mischief" genre. The premise is fun. The question is: how do you keep it going? After a few gags, what's next? There are only so many trampolines you can stick in his parents' backyard before the viewer is going want to know where this is going.

To me, it feels like it's headed toward a big lawsuit, with the mischievous kid feigning tears and saying:

> KID: *I was only trying to be the son you wanted me to be.*
>
> DAD: *You spent my life savings on time-shares in three amusement parks!*
>
> SON: *I thought you liked the Fun House.*
>
> DAD: *When I was twelve!*

With the premise firmly established, we can develop the characters further. Some students at the kid's school who had previously ignored him might suddenly want to be his best friend. (And borrow a trampoline.) The father's coworkers might poke fun at him, but they also notice that time-shares at amusement parks are going up ten percent this year, and they wonder how his son could be so financially savvy. These scenes bring out a human element, which is much needed:

- We see who the kid's real friends are and who they aren't.

- The father realizes that his son's purchases were sophisticated and has newfound respect for him.

Ask yourself these questions:

1. There's an idea here, but is there a story?

2. Who does it appeal to?

3. Ultimately, which character gains what from this experience?

For children's picture books, thin concepts, if well crafted, are often more than sufficient to carry the story. There is frequently a lot of repetition, which is part of the charm. It's like a three-act structure without the second act.

Before you dive in to begin a big project, ask yourself, "Am I the right person to do this?" You may have come up with a great idea for a martial arts movie, but if you have no familiarity with the martial arts, it could be a slog. You may feel more inventive with an idea if you have experience with the subject, which could also lend a feeling of authenticity to it. Does the idea stimulate you to come up with more ideas for the story? If thoughts leapfrog from the premise, then stay with it and see where it takes you.

Finally, and perhaps most importantly, is the idea so good that none of these questions make a bit of difference to you, and you've just got to do it? This is a valid consideration. Sometimes an artist has a gut feeling, and no amount of reasoning can change it. I respect that. Everyone can give you advice but you're the only one who gets a vote.

WHAT ARE YOU TRYING TO SAY?

What are you trying to say with a drawing? Professional artists ask themselves this question often and you should, too. There are so many elements to choose from when you create a character or a scene. Ultimately a drawing must be about one thing, and the other elements, even essential elements, will revolve in its orbit.

The more specific you can get when articulating what your character or scene is about, the clearer you can communicate it. "What's the drawing about?" is more than a question, it's a technique. Of all the techniques in this book, this is perhaps the most important. Let's find out how to use it.

One day I stopped at my mailbox. As I retrieved another unwanted solicitation, I noticed, not ten yards from me, a delicate fawn lapping water that had collected on a tree stump. It was then that I saw the mother standing over her, head turned back to face me directly. The mother stared into my eyes. It was unmistakable what she was telling me: not one step farther. I took a step back slowly and quietly walked away as she watched.

What was that scene about? Love, pure and simple. There are many other words you could use to describe it: "caution," "vigilance," etc. But unless you were drawing a picture about love, you couldn't capture it.

Let's try this out on a different subject: imagine an artist drawing a scene who does not fully appreciate the singular nature of her own

You can find creativity in the way you transpose an idea. It may not be a deer and her fawn, but it expresses the same idea.

concept, but instead is focused on its elements. She sets out to draw a girl and a horse who are best friends. That's the concept. She roughs out a girl and draws her arm outstretched to pet the horse's head. Already, the premise is in trouble. Why? Because she sketched a girl and a horse, not best friends, which is the basis for the drawing. How can I tell? Let's look closer.

The girl's arm is "outstretched," which requires distance between the girl and the horse. You now have a girl and a horse standing at arm's length from each other. That, combined with the formal head petting, does not show the ease and intimacy of best friends. The thing that's so charming about the premise is that the girl and the horse are friends just like how two people could be friends, but that's not what the artist is drawing.

What could our artist do to correct this? She could start by positioning the characters closer to each other. If the animal considers the girl its best friend, it will react in kind. How does that look? The horse could lean its head in the direction of the hand petting it, closing the gap between them. You can emphasize this moment so the viewer won't miss its significance; the long mane might sway as the horse leans in— all in service of showing the bond of friendship.

How does a beginner make this work? Simply ask yourself from time to time if what you're drawing is what the idea is all about. There will be many areas of a drawing where you won't need to apply this line of thinking. If you're drawing trees in the background, then who cares what the premise is about? You're just drawing trees (unless they're in front of a gothic castle).

> **Ask yourself from time to time if what you're drawing is what the idea is all about.**

Adjectives work better than nouns in bringing a concept into focus. They're more specific. For example, *effervescent* is better than *smile*. *Standoffish* is better than *introvert*. You can come up with your own descriptions and meanings. The takeaway is simply this: the more specific your idea is, the more effectively it can be communicated.

THE HUNCH: UNSUNG PROBLEM SOLVER

Most people think of a hunch in terms of an intuitive guess. Like, if I buy gold, its price will go up.

A creative hunch is different. When an artist gets a hunch, it's usually not reasoned out. Something just clicks in their brain. This can occur anywhere—in line to get a coffee, riding the train. You can often tell when someone has a hunch. They murmur things like this to themselves:

Why didn't I think of that before?

So obvious . . .

Wait . . . yeah . . . !

There's a difference between an idea and a hunch. You can work with an idea. You develop it. Not so with the hunch. It's like getting a tip from your imagination. It's here and then gone. Getting a hunch says something about the quality of a project. I've never gotten a hunch about a poorly conceived idea. It's always been about something with potential, but with a piece missing.

Often a hunch is a small adjustment that will transform an idea. These gifts of unexpected perspective are written into the DNA of artists and writers. You get them only when you're relaxed or distracted, so you can't cause one to occur, but they can be overlooked. When that happens, they go back to Hunch Land, which is why professional writers and artists jot them down as soon as they get them. You should, too.

Another difference between a hunch and an idea is your distance from them. When you have an idea, you want to examine it up close, discover things about it, and tinker with it. But when you have a hunch, it's the opposite. You want distance. You want a wider point of view so you can observe the problem from new angles, all of which are filled with possibilities.

Here's what it feels like to have a hunch: suppose you've been working on an assignment to draw a public service announcement about a traffic jam. Your artwork demonstrates it but doesn't quite convey the commute from hell.

You decide to put the drawing aside and buy a pair of running shoes. As you walk through the door, an image comes to mind. A traffic jam

as viewed from a high angle. Now you're looking at a long stream of cars, going into the distance. That's all you get, one image. But that's all you need.

Hunches usually announce themselves. If you don't want to miss it, be on the lookout for the following clues:

- It's a feeling of excitement about an idea or project that seems out of place.

- A vague sense that your work is tugging at you, wanting you to return to your drawing board.

- An idea suddenly pulls at you from one area of your brain: maybe the top, maybe the back, or maybe the front.

- It feels like you've thought of this before—but you haven't.

Don't stop what you're doing. You never know when it may happen. Just be ready. This is your imagination's way of sending you a text message.

GOING DEEPER

Drawing isn't only about "feeling it" or technique, but about both. You can stretch the imagination by sticking with it and expecting more from it. In this chapter we'll explore ways to push it further.

YOU ARE HERE

Have you ever hiked through a national park? Imagine you're walking and walking, and as you start to doubt your sense of direction, you come upon a map posted into the ground that shows you where you are and how close you are to your destination. This chapter will give you a sense of where you are as an artist and where you want to go.

Becoming a better artist is not as clear of a path as becoming, let's say, a lawyer. Lawyers get a degree, get a license, join a law firm, and write threatening letters. As an artist, your ability to create engaging art increases as you gain greater access to your imagination.

> **As an artist, your ability to create engaging art increases as you gain greater access to your imagination.**

Technical ability and the imagination are two different things. Someone with good technical skills might draw a series of birch trees. The artist with greater access to their imagination, who might not be as accomplished, would also draw birch trees. But those trees might be festooned with holiday lights, and decorate a small town's Main Street. The imagination is always reinventing itself. It is a wandering thing—restive and curious.

The goal is to marry your artistic strengths: your ability to draw and your ability to imagine. Drawing skill and the imagination work hand in hand. Let's take a look at where you are now, where you want to go, and how to get there.

THE BEGINNER ARTIST

Drawing skills: If you're a beginner, you have probably tried a bit of this and that, but then settled around a few subjects or a genre you feel comfortable with. When you find something you draw well, you stick

with it. You like drawing it, and your art reassures you that you have some skills. Perhaps you've also gotten a few nice comments on your work. You're off to a good start.

As you go forward, rather than trying to perfect your drawings, try tackling new characters, subjects, and techniques, with no expectations. You're like an explorer. If you come upon a gold nugget, great, but if not, you're still enjoying the hike. Because you haven't put pressure on yourself to be perfect, you can afford to be bold in trying new things, to stretch and experiment.

Imagination: At this early stage, your imagination may be a step ahead of your drawing skills. This is to be expected and will even out as you progress. Pare down your more complicated ideas so they communicate a feeling, a mood, a concept, or an irony. The technical stuff will come. The future for you is not that far away. Keep going.

THE DEVELOPING ARTIST

Drawing skills: The art from a serious beginner may look similar to that of a beginner but every so often there's a flash of inspiration—something impressive—that shows up on the page. You may not be consistent, and therefore you might not view your over-the-top moments as skillfulness, but I beg to differ. If you have such a moment, even once, then something is going on in you that isn't going on in non-artists. Chase it down like a dog after a ball. In any event, the question arises: should you look to capitalize on the flash you've shown in a few select areas or subjects or should you continue your efforts to improve a broad base of skills?

Here is where I differ with some people. I agree that everyone needs to learn the fundamentals of art, but if you can get up to the plate and hit home runs, then hit home runs. And keep hitting them. In life you have only so many opportunities to get into the batter's box. Don't step out because you didn't practice catching enough. I am not saying to forgo

an art education, but it's smart to prioritize. I'll have more to say about this in a few pages.

Imagination: One hallmark of the serious beginner is their willingness to draw something because it would look good in their picture—regardless of whether they have figured out how to do it or not. This person is beginning to use their imagination as a tool kit—venturing out into new areas here, retrenching into familiar territory over there. When someone has these considerations, they are doing more than just drawing, they are searching for creative answers. This is very cool.

THE ASPIRING PROFESSIONAL

Drawing skills: Artists who consider art a serious hobby or a profession often receive a different type of comment on their work from people. This is typically: "How did you draw that?"

I'll translate this comment for you: "I didn't know you were that good."

The observer doesn't quite get what to make of your talent. They feel that they didn't know an important aspect of you before. It's similar to this: let's say you went to a friend's house for dinner. You didn't know this friend was a chef. You sit down to dinner. Everything tastes like it came out of a restaurant. "You cooked this? This whole thing?"

That's how aspiring professionals appear to others, but with a pencil.

At this stage, you can often draw a subject, even if you have never drawn it before. It has a visual logic that you see and understand. Here, you are within striking distance of becoming a professional.

Imagination: At this point, allow your imagination to inform your ideas. In other words, instead of looking at the drawing to see if it's right, look back into your mind to make sure it's what you meant. Your imagination is your compass now. It may come even come up with

ideas you can't use. This is a positive development. Your imagination is generating ideas without regard to your ability to draw them. It has freedom and will do more for you now. This is paradoxical—an imagination that goes off on its own, to solve problems for which you may not need answers! This widens the orchard of ideas from which you can pick any time you need or want to.

THOSE REDISCOVERING A PASSION FOR THE ARTS

There are many people who used to draw but, because of professional or family circumstances, life took them in a different direction. The urge to create has never left, and they want to give it another try. Similarly, there could be people who, without ever having tried the arts, find themselves drawn to them at a later stage in life. This is not a small population; many dive right in and, before they know it, are creating wonderful and ambitious works.

With varied backgrounds and careers in places other than art, it's sometimes hard to figure out what to draw or paint. I'll make a suggestion—*anything*. That's right, anything is a good place to start. The vases with plants next to your front door. An old wheelbarrow by the garage with paint cans in it. Spend an afternoon at a local beach, which can be a great place to paint (and get onion rings). Or perhaps you like cartoons and kawaii (Japanese-style cute characters). You could also start off with the last subject you remember drawing. If you drew superheroes in high school, or comic strips, or horses, then start with those. You may be surprised by how fast you pick things up again. When you feel you're getting back into your groove, you can venture out to something new.

REACHING FOR THE NEXT LEVEL

Reaching for the next level with your art—as I define it, as you define it, or as someone else defines it—brings the hope of new ideas, goals, and

expectations. Here are a few suggestions to keep you progressing on your creative adventures.

BE CURIOUS

Being curious has a slightly different meaning than being open, at least from an artist's point of view. An artist who is open takes in experiences in order to re-create them later. Being curious, on the other hand, means looking past the obvious and imagining more. The artist may have no idea how to make his vision work, or if it could work at all. But it's that childlike leap of faith that often brings the answer.

One of the most valuable attributes of an experienced artist is a creative curiosity. This takes the form of self-directed questions, such as: how can I get this wishing well to look magical? Beginners can borrow this same mindset to dig deeper and dream further.

COMMUNICATE

Communication for artists can be thought of in terms of something that flows from you to the viewer. You want to convey a feeling, for example. But if your drawing doesn't communicate what is in your mind, it won't be received by the viewer, no matter how much you feel it. If you want to say something and you want it to be received and understood, it must be there on paper.

DON'T BE AFRAID OF CORRECTIONS

For artists, there are several types of corrections. The most common is where you fix a problem, which—of course—is important to do. However, I'm talking about something more aspirational. I'm referring to where you spot an opportunity in your drawing that is almost done. Why change it? Because you have a better idea. And you are a creativity machine. Apparently, you have many good ideas. We should all have such problems. I think they call that "an embarrassment of riches."

TRACKING YOUR PROGRESS

Chances are that others will recognize your progress before you do. It's also important to acknowledge when things are going well. It's harder to build on progress if you don't know whether you're making any! You could ask people for their opinions on your art, but the person viewing it might not know what they are looking at. Who would you ask, anyway? Family? Friends? They're not impartial but there's another way to find out without asking anyone. There are signs—if you know what to look for and how to read them—that could give you some clues.

I've put together a list of fourteen items that point to positive changes in an artist's skills. If you don't identify with the points on this list, that doesn't mean you're not improving. However, if you do see yourself in here, you're not a beginner anymore.

1. Drawing takes longer than it used to, not due to difficulty, but because you see more possibilities.

2. People occasionally ask you to draw something for them, even if it's not a professional request.

3. You choose things to draw because you want to learn how to draw them.

4. You look at other artists' drawings to see how they handled a subject.

5. As you draw, you consider how the viewer might experience it.

6. You spend more time thinking about *how* to draw something than *what* to draw.

7. Sometimes, out of nowhere, you get an insight about a recent sketch that's been giving you trouble.

8. You find yourself staring at something so you can remember it and draw it later.

9. People want to know what you're going to draw next.

10. People tend to linger over certain subjects you've drawn longer than other subjects. (Take note of what they are.)

11. When people look at something you've drawn, they begin to talk about similar subjects they enjoyed drawing when they were younger.

12. People ask you how long it took for you to draw something (and it didn't take that long).

13. You draw a genre well, but it bores you. (This is a very positive sign.)

14. You drew something to elicit a specific emotion on the part of the viewer and that's precisely the reaction you're getting.

A SIGHTSEEING TOUR

Before we go on, I want to share something that helped me early on. When I was first learning the principles of drawing, they seemed technical. I wasn't sure if things were supposed to converge along vanishing lines at some point in the distance, or to the side, or in the middle. All I knew was that everything was supposed to meet somewhere. But were there really vanishing lines in life? I didn't see them.

What about lines flowing into other lines? Where were those? I could draw them, but was I drawing anything that was represented in reality? In figure drawing, I didn't see a person's hips tilting up and down with each stride. Yet here I was, drawing it.

I decided to go on a sightseeing tour—a tour of the visual arts—not one featured in museums or galleries, but in life itself. I took no art supplies, no pad for drawing or jotting down notes. I was going to make the laws of visual arts prove to me what was being taught in the classroom.

For the next two weeks, wherever I walked, wherever I sat, I followed the vanishing lines. As you probably know, these lines travel back to the horizon. And even if you can't see the horizon, they converge where the horizon would be if you could see through whatever is blocking it from view. They're an organizing principle for maintaining perspective throughout a picture (the picture plane).

So, if I was in a theater, while everyone else watched the show, I was looking at the left side of the room, where the wall met the ceiling, and the right side of the room, where the wall met the ceiling. I would follow these lines as they traveled toward the screen. They were perfectly in sync with each other, converging exactly toward the center of the screen at the same rate and angle. Maybe they were just doing this because I was watching. Like a probability wave for the arts. Kind of doubtful, though.

The technique of overlapping pulls disparate elements together, and is an economical way to include more on a page.

Outside, I looked as overlapping lines defined mountain ridges and cloud formations. I noticed as passersby walked according to the dynamics of motion. I was, in all seriousness, somewhat amazed. Life imitates art and art imitates life. Every time.

You can get a ticket to the same tour. It's free.

THINK BEFORE YOU DRAW

The earlier in a project you conceptualize your drawing, the more effective you will be once you begin to draw it. Waiting until you're halfway into a drawing before considering your approach limits your options. Don't strike while the iron is cool. Kick around some sketches first. Choices put you in charge, which is a good mindset for a creator.

Let's consider what could happen when an artist begins to paint without first considering the subject from a practical *and* artistic point of view. Let's say you want to paint a sailboat. Towns all over America hold art fairs each year featuring paintings of sailboats. One of your goals in painting a sailboat is to stand out and show your talent . . . but wait, we just hit a speed bump. If there is an abundance of sailboat paintings and yours is one among many, then painting a sailboat would not be a good strategy for standing out, which is your goal.

Part of the problem is that sailboat paintings are often painted the same way: here's the harbor, here's the water, here's the horizon, here's the peninsula, and cue the seagulls. As a result, sailboat paintings have acquired a sort of doctor's office look to them.

Find a new way to express something. Explore an uncharted avenue.

You can achieve both of your goals— painting a sailboat and standing out from the pack—by conceptualizing your scene differently. A few quick sketches executed in advance, where you take chances and try

For the cover illustration of this book, I drew a number of roughs. Often, I draw variations not so much to work out each idea, but to see them in context. By placing different versions side by side, I can see which works, and I can also borrow good elements from ones that don't. I chose the tall cat because she's slightly more sophisticated and appears to be accessing her imagination. Which would you have chosen?

new things, could yield interesting approaches, from which you might choose one or combine several. You're not married to any of them—they're rough, and they have a name: concept sketches.

Remember that there's more to drawing than drawing well. There's also drawing interestingly. Play with your audience's expectations. Find a new way to express something. Explore an uncharted avenue. It's cool, it's fun, and people like it.

INSPIRATION COMES IN WAVES

Creativity has peaks and valleys. No matter where you find yourself along the way, it's important to keep moving forward. If you're bubbling with ideas, keep going; it won't last forever. If you're in a valley, keep plugging away; inspiration will return.

There's the popular trope that urges artists to take a walk along the beach so the ideas will flow. This approach doesn't work because it's not a path toward creativity but a flight from it. How many artists and writers have you seen on the beach furiously jotting down notes? If you didn't have valleys, there wouldn't be peaks. Sometimes we feel that our imagination has petered out when it's actually in a trough, gathering energy to turn itself into the next wave.

Stay with the idea but pull back, relax, and get a broader take on your artwork. Look at the big picture. Imagine the logic of the drawing. Sense it. Follow its lead. That's often the way back in. Where does the drawing want to go next? If you can't figure it out, maybe you can feel it.

MAKING CHOICES

What a great world it would be if something completely formed and original popped into our heads when we wanted it. But that's not how it usually works. Most often, artists begin with something ordinary. This becomes a template, and

Variations can emerge from random placement.

by adding some of this and taking away some of that, eventually an original idea begins to emerge, at which point the artist can go in and take it the rest of the way.

Let's say that you want to come up with an original drawing of a dog. Think of a dog that no one has seen before. You can't. Neither can I. So how do you go about it? You make choices. The more choices you make, the more original the dog will be.

I've compiled some choices to consider. As you begin to make certain choices, you'll notice that something interesting starts to take shape. Your dog takes on a unique appearance. The choices add up to originality, and this happens even if the individual choices aren't particularly original.

1. Breed (or mixed)
2. Age
3. Coat (long hair, short hair, knotted, curly, silky, wiry, clean, messy, etc.)
4. Angle (front, side, three-quarters, etc.)
5. Color(s), as well as patches of color or spots
6. Pose (portrait, standing, sitting, take my paw)
7. Emphasis (big chest, long tail, dangling ears, tiny nose, short or long legs, etc.)
8. Expression (friendly, guilty, bored, alert, etc.)
9. Accessories (collar, leash, bandanna, doggy vest, chew toys, etc.)
10. Energy level, personality
11. Size
12. Location (interior/exterior)

Ideas are like items on a buffet table, but it's a buffet you create. Choose a couple of these, one of those, and two of that other thing. Sometimes it's easier to lend originality to a big concept than to a small one because there's more to work with. When I say "concept," I'm speaking of scenes and situations, which can also be inventive. Continuing with the dog theme, let's start with a pup standing on a sled in a backyard. This is a cute beginning, but don't stop here. What else could you do with it? How could you add a few touches to make it more original?

Don't allow your ideas to be constrained by considerations of whether they are too difficult to draw. If you think of a wonderful idea that's somewhat beyond your capabilities, you can create a simpler version that will accomplish the same thing. Here are a few examples.

- A boy sits on a sled next to his dog, which stands on its own sled. There is a slight slope ahead of them. The boy signals with his arm that they're ready to go.

- If snow has collected on the sled and the dog, then the scene tells a story: the poor little doggy has been waiting a long time for someone to join him!

- The dog is sitting on the sled but facing the wrong way (uphill). The boy stands by him, arms akimbo. (An arms akimbo pose gets cuter the younger the character is.)

NEVER FALL IN LOVE WITH A DRAWING THAT ISN'T WORKING

Many artists have experienced the following situation: you're convinced that a drawing—which refuses to work—should work, and so you decide to stick with it no matter what. There may be honor in never giving up but not this way. Certainly not by turning your drawing into an opponent that needs to be conquered.

Let's say you've put in a lot of effort but have not made progress. Making small technical corrections will rarely save a drawing in trouble. It may be time for a bolder approach. Are you ready for it? Get rid of the drawing. I know you don't like that idea. You still want to make it work. But the more you try to "fix" it, the more "not-working" it gets. Professional artists are quick to raise the white flag because they know their imagination can come up with an alternative faster than they can fix the original. And even if you do start over, you don't have to lose the original. File it away for later.

> **Making small technical corrections will rarely save a drawing in trouble. It may be time for a bolder approach.**

One morning I came up with an idea for a drawing. As I started to illustrate it, practical considerations began to intrude on my brilliant concept—things like layout, style, etc. My idea was proving resistant to these essentials. I worked on it, reworked it, and reworked it some more.

It was during this time that I noticed a half-drawn sketch off to the side of my desk. I was thinking I should file the sketch for later but there was hardly anything there worth keeping. I returned to my original drawing. Finally, after seven drafts, it worked. It was everything I had hoped it would be, but I didn't like it. All the effort and corrections I put into it sapped the life out of it. One thing I've learned in all these years as a professional artist is not to talk yourself into liking something that you don't like.

I picked up the half-drawn sketch again—I don't know why—and placed it on my light pad. I put another sheet of paper over it and began to draw. I finished it in under an hour. It was exactly what my original idea should have been but wasn't. However, not for a moment did I regret all the unusable drafts that preceded it. I couldn't have gotten there without them. And the original I loved so much? I didn't even save it.

When we're not feeling inspired, we tend to draw the same thing over and over again, crystallizing our mistakes instead of closing in on a solution. The impulse to keep going is a commendable one, but stay loose. Pause. Regroup. Then go at it again. One of the most effective methods of dealing with an uncooperative drawing is to trace over it and make changes. But don't trace with the exactitude you used to create the original drawing, or it will defeat the purpose. Bring something new to it.

WHEN TO GRUMBLE

There are times when every artist has to draw something repetitious, like the slats of clapboard running across a colonial-style house in a suburban scene. Backgrounds can challenge one's patience. The first few clapboard slats might be somewhat engaging to draw, but I guarantee you that the thirty-ninth slat will not. So what do you do?

Be prepared to be bored. This is endurance management, and you need to stay focused. Take a take a deep breath and get ready to do what needs to be done. Draw each slat as if it's the first one. The main thing is to resist the impulse to rush through the uninteresting part. It will be a challenge whether it takes forty-five minutes or an hour. If you do a mediocre job to finish quicker, you may have to do it over again. Spend the extra fifteen minutes and get the result you want and deserve.

> **When we get super granular, we can easily lose our way.**

While you're toiling in the coal mine, take a pause every fifteen minutes or so. Stand up and look at the piece as a whole. Make sure you're drawing what you had intended to draw. When we get super granular, we can easily lose our way. You could end up covering an area with clapboard that was supposed to be trees!

DRAWING FOR PERSONAL ENJOYMENT

Everyone who likes to draw finds it an engaging activity. As we improve, this enjoyment continues, especially in our sketchbooks, but at some point the pleasure we derive from it can actually slow our progress. It sounds counterintuitive, but here's what I mean.

Let's say that an artist loves to sketch people. She's come a long way in developing her skills. In her free time, she draws the same faces and outfits. She may have gotten quite good at drawing them. And it's a good feeling, drawing something that she's mastered. When she starts her drawing, she knows it will end up looking good. It also gives her confidence.

This immersion in familiarity may actually be holding her back. We continue to improve only if we try to climb new mountains (little mountains, but mountains nonetheless). Without trying something new, we stagnate. We must keep challenging ourselves (little challenges, but still challenges).

This is a very common problem. In fact, it happened to me when I was sixteen. I had drawn a great character design chart (I thought). But I avoided one angle of the head because I couldn't make it work. I thought the omission wouldn't be noticed but it was, right away, by a professional animator I showed it to. Back to the drawing board to work on that angle. I had been hoping to come away with a compliment, but I left with something more valuable.

SHOW-AND-TELL

You may occasionally feel the need to get an outside opinion on your work. Maybe you're trying to choose between two approaches, and you'd like another point of view. Here's who you should ask: anybody. Really. It doesn't matter if they know a thing about art or the subject you're drawing. It doesn't matter if they're articulate. It's okay if you disagree with their opinion. All that matters is that they have one.

COMMENTS AND COMPLIMENTS

Nonprofessionals may be reluctant to offer suggestions for artwork that appears to be finished. They don't understand the concept of redrawing. They wonder why you're asking for their opinion, if it's finished. Therefore, show them two versions of the same drawing. You probably have four or five earlier drafts. They don't have to be in the same shape. They just have to be different. By showing two versions, you can elicit more opinions. You can also guide the opinions in a useful direction. How do you guide an opinion? Like this:

ARTIST: *Which do you like more, this one or that one?*

MR. AVERAGE PERSON: *I like the one on the right.*

ARTIST: *The one with the hat?*

MR. AVERAGE PERSON: *Yeah, that one.*

ARTIST: *What if he didn't have a hat?*

MR. AVERAGE PERSON: *I still like him.*

ARTIST: *What if I erased his hat and put it on the guy on the left?*

MR. AVERAGE PERSON: *Oh. Now, that's hard. I guess, maybe, the guy on the left.*

ARTIST: *So maybe the hat is important.*

MR. AVERAGE PERSON: *Yeah, very important.*

You just hit solid ground. It took only a few questions. Why care about the opinion of someone who has no particular interest or expertise in art? For the same reason car design is meant to appeal to people without an engineering degree. If he likes the hat, other people will like the hat. You're not asking him how to draw it. This isn't a critique. It's a poll.

PEER TO PEER

For ongoing feedback at a deeper level, look to cultivate friendships with other artists. Two artists of similar but not necessarily identical skill levels can encourage each other and have a friendly competition that helps both improve. Like-minded individuals can be found in art classes, art associations, or wherever you spot a good opportunity. Peer-to-peer meetings can be held at a coffee shop, online, or wherever you like.

Every artist at every level needs feedback.

Don't assume that only the less experienced artist gets something out of the experience. Every artist at every level needs feedback. If a more experienced artist asks for your opinion, don't doubt yourself: give it.

By showing two versions of the same character, you can elicit helpful comments. Remember, your viewer may not have your imagination. They may need a little help articulating their preference.

It's your chance to reciprocate his input. All he wants is for you to be thoughtful. That will sharpen your observational skills, which will help you as well; you may find you're making comments that you ought to implement in your own work. Regular meetings with someone along these lines can turn into a professional association and sometimes even a lifelong friendship.

So what do you bring to such a meeting? I recommend a few of your best pieces and one piece that's been giving you problems, which you could discuss. Perhaps there's a perspective problem you haven't been able to solve. Your art colleague will immediately understand where you're coming from and together you could go about trying to devise a solution.

If you have the opportunity to show your work to a professional artist (perhaps at a convention), don't argue if they don't love a particular piece. I can't tell you how often this happens, and it's the exact wrong way to behave. The pro may not be right, but their reasons will be informative. Thank them even if you have to chew on a twig to get it out. You might change your mind a few days later and end up agreeing. Or not. Either way, act like a pro. If someone approaches a professional artist at a convention, such as a comic convention, to ask about their work while you're trying to get advice, step back. Give them room. The way you preserve a professional contact is by being respectful.

WORDS *and* PICTURES

Not all illustrations benefit from the addition of words but illustrations paired with writing represent an important market for artists. It might be something you should consider. Let's explore it.

What is it like to write words to go along with your own pictures? You have this opportunity when creating children's picture books, graphic novels, animation, comic books, nonfiction books, and comic strips. Illustrations create emotions, situations, and environments but words can spell out what a character is thinking with precision as well as refer to the past or future. One effect of matching words to illustrations is that the viewer may lose some independence in that they cannot choose how to interpret a picture because it has been done for them with words, but they also gain in clarity of the artist's intent.

CHILDREN'S PICTURE BOOKS

Do you remember your favorite childhood picture books? I do. For some people, these books are among their earliest and fondest memories. The beautiful illustrations and stories were like wondrous lands to travel to, and to visit over and over again. My mother used to buy insanely exquisite children's picture books. They are now tattered but still on top of my dresser.

Drawing and writing a picture book allows you to relive and share these times from an entirely new angle—as a creator.

This is from a cute children's book I did about three puppies who wanted to grow up to be police dogs. This one wrote himself a ticket for having an accident.

Some books can be charming, while others are funny and irreverent. It's a personal journey, but—like all art that is intended for viewers— keep the sensibilities and age range in mind.

Drawing with text can help to keep you on track as an artist. For example, if a line of description talks about how it was a snowy night, that tells you what to focus on. Not the dog in the house, or mom catching up on her work on the computer, but the snow coming down on the trees, perhaps as seen through a child's bedroom window.

The illustrations should tell the story, but there is almost always some text. Here are a few ways in which the text serves the illustrations:

- Introduces or recaps a scene

- Builds anticipation for the next page

- Explains a concept that can't be adequately described visually

- Provides dialogue

- Adds context to a moment

- Comments with a moral angle

- Comments with a joke

- Underscores a mood

- Repeats a line of dialogue or a sound effect that becomes a signature phrase of the book

Publishers may request a creator to submit only a written manuscript. They might prefer to select an illustrator they believe will match the written material. Check publishers' websites to see how they want material submitted. I recommend following the publishers' requirements. Fewer headwinds that way.

Nevertheless, some authors may feel it is imperative to submit a few visuals with their manuscript. While it is preferable to follow a publisher's submission guidelines, there are a few methods I have used in order to include illustrations with the presentation, while trying not to overwhelm an editor. I've successfully used some of these while submitting children's books, how-to-draw books based on novel concepts, and a graphic novel. But they might come with some risk.

- Send the manuscript with a sample cover illustration.

- Send the manuscript with a sample spread of an important part of the story.

- Send the manuscript with a brief snapshot of each character, including an illustration, their name, and their role in the story.

- Partner with an illustrator who is well known.

- Suggest that sample illustrations are available, should they want to see them.

As for agents: "literary agents" generally represent writers and writer-illustrators. An agent who primarily represents visual artists is called an "art rep." An agent who primarily represents art licensed for different products and media is called a "licensing agent."

ANIMATION

Animation offers myriad opportunities for artists. It has many areas of specialization, including writers, animators, character designers, background artists, storyboard artists, and concept designers. For the ambitious, there is also the possibility of working your way up to directing and producing. Subject matter runs from very young to adult. The styles, types of media, and genres can vary widely.

Many writers in animation come from an art background, which makes sense. They understand the frenetic, humorous actions and amazing fantasy realms that are possible in the art form. If they can imagine it, they can write it.

A sort of in-between stage between writing and drawing is the storyboard artist, whose job is to draw loose sketches representing the key moments in a scene. These look somewhat like a comic strip and are done for the entire TV show or movie; they help everyone, from the director to the animator, visualize where the action is headed.

There are giant animation studios, small studios, and independent studios. Most people in animation loved watching and drawing cartoons as a kid. They're not just artists; they're fans. But that's not a requirement. Some artists migrate over because of opportunities, the desire to work on staff and be in the company of other artists, the benefits, or because their style works well with a studio's projects. Many art schools teach courses specific to animation.

GRAPHIC NOVELS

A graphic novel is a dynamic format and found in various genres including (but not limited to) manga, comic books, drama, horror, contemporary issues, and more. Check the shelves and see what readers are reading. People have asked me, which comes first, the writing or the art? Usually—but not always—the words come first. That gives the artist the concepts they need to draw. Think of how awkward it would be if the art came first. It would be like having actors in a movie say their dialogue before there's a script.

Sequential artists who work in graphic novels, comic books, or comic strips visualize the story and characters from a script. The layout of the panels is a pacing tool that moves the story along. Some artists get quite creative with panels, such as using the entire page as a single, splashy shot with a few smaller panels inserted.

Selecting panels is more than figuring out the dimensions. It's also about what to show when. Arranging and rearranging panels is part of the creative process for sequential artists. If you're the type who thinks in terms of panels and layout, then being a storyboard artist could also be something to consider. It's a similar skill.

To create original characters for your graphic novel, you'll also need to draw upon character design skills. In this way, graphic novelists have something in common with film animators.

CHARACTER DESIGN

Before you can write about your illustrated characters, you have to bring them into existence and develop them. It's not enough to *tell* people who your character is, you have to *show* them. Character design is important in any area of art where the same character is drawn many times, in a variety of poses, expressions, and so on.

There's more to character design than rattling off a couple of drawings. Your creation's traits must endure over multiple pages with proportions that are maintained. If you have a suspicious character, for example, it should look suspicious so you won't need to write about their mindset every time you reintroduce them. This will free you up to write about other things in the story. Certain traits are chosen to persist in the character, which underscores their identity, such as the outfit, hairstyle, posture, etc.

To stay on point, many creators write up a short list of personality traits to help them form the character. These can even include a brief background of the character, which could be used to give a type of logic as to why the character does what they do.

Each character is unique but works within a cast of characters based on a visual theme or style they all share. A group character design chart involves a cast of characters, and compares multiple characters drawn at different heights, with different postures, builds, etc. For

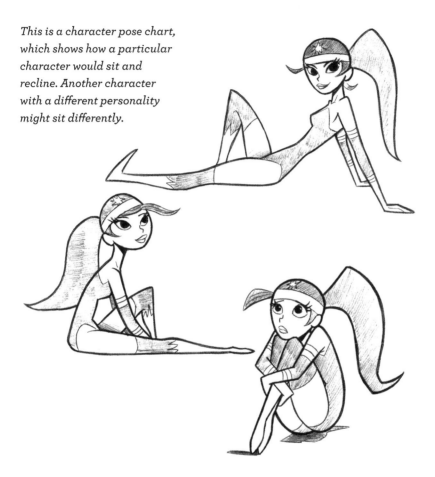

This is a character pose chart, which shows how a particular character would sit and recline. Another character with a different personality might sit differently.

example, if one character is tall, another might be short so there is variety. Everything relates to or contrasts with the other players—even outsiders, like a passerby, would appear to be of a similar style. Animated characters must be well worked out because the same character will most likely be drawn by different animators, but must always look the same. The usefulness of a character chart goes beyond that—drawing them is an excellent way to develop and refine your skills. Therefore, if you've drawn a character you like, try turning it

into a rough character chart. It's great practice and the result might become a portfolio piece for you.

COMIC STRIPS AND WEB STRIPS

Comic strips, once the sole province of newspapers, now appear across many media platforms. Although the character designs can be whimsical and entertaining, comic strips rely, by and large, on the ability of the artist to write a good setup followed by a punchline. Comic strips and web strips rely on words to make their point.

If you have an idea for a character or characters in funny situations, you might have the beginnings of a comic strip. Can you write jokes? Can you do it more than once? How about all year long? A strip is a carnivorous animal, rapacious in its need for material. Because so much material is used, it has the ability to pull the reader in, sometimes daily, and—as a result—you could develop loyalty to your brand.

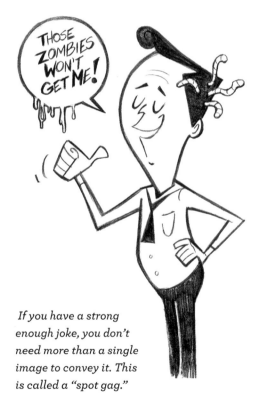

If you have a strong enough joke, you don't need more than a single image to convey it. This is called a "spot gag."

Writing jokes to accompany illustrations isn't the same as writing prose. Jokes require a setup and a payoff with a hard or a

soft punch line. If it's not a humor-based strip, then the resolution to the very short storyline lies in next week's strip so that the reader has to keep reading.

Although comic strip artists (and those who create sequential art) introduce a new character from time to time, they basically work with the same cast, which sometimes evolves over time to keep current with trends and fashions. A comic strip artist may be happiest working out the antics of recurring characters. And because such characters become established over time, they may have more perceived value as properties for licensing.

Another type of comic strip is created with a single panel. These are called "spot gags." They frequently show up on merchandise and textiles because they are succinct.

GREETING CARDS

My opinion on greeting cards is that physical cards retain a perceived value over digital cards. A digital card is something you read, but a physical card is something you save. You can give paper cards to someone by attaching them to a present as opposed to sending them digitally. They also convey sentimentality in a way that isn't as easily communicated digitally. There are custom cards, ones based on licensed characters, and elaborately crafted cards with pop-ups and such. If you can imagine it, you can design a card for it.

APHORISMS ON MERCHANDISE

A lot of inspirational merchandise is created and sold by artists directly to the public. Art, gift, comic, and manga conventions are replete with craft artists. Some also sell into retail stores and/or have their own online shops. Various characters have been reproduced on all types of merchandise, including books (such as journals), sculptures, figurines, T-shirts, mugs, backpacks, and more.

MORE CAREERS IN ART

Many of the well-known professions for commercial artists have been discussed in this chapter. Here are a few more interesting options you might want to explore:

- Art direction

- Theme park concept design

- Computer game and app design

- Advertising

- Toy design

- Tattoo design

- Set design

- Fashion illustration

- Pet portraits

- Creating a library of your own stock images to license

- Starting your own agency to represent artists

SEEING
Like an
ARTIST

I've encountered a common problem
many times when giving drawing
demonstrations. While attempting to
show beginning artists how to draw a
person, animal, or thing, they see their own
creation inaccurately.

For example, I might draw a diagonal guideline on a face in order to make is easier to draw. But, trying to follow along, a beginning artist might draw it horizontally. That's not a drawing problem, it's an observational problem. This is a great problem to have because it can be fixed and quickly lift you to the next level.

Once you realize that your observational skills are as essential as your drawing skills, you can pause at any time and adjust your drawing to match what you see or imagine. This is the point at which the beginner stops being a beginner and takes another positive step into artistry.

OBSERVATION 101

To draw like an artist, *see* like an artist. It doesn't take a special skill, but it requires that you notice things from a particular point of view. Here's what I mean.

Let's say you're looking at a chair. What do you notice first?

The outline. I see the lines that define the chair.

Good. What else?

The direction it's facing. It's turned slightly to the right.

Anything else?

Yes, I think . . . the distance. It's close to me, so there's not much of an effect from perspective.

You're on a roll. What else?

The shadow. Half of it is in shadow.

One more?

The contours. It has that soft back and seat.

This is precisely the reverse order of how a non-artist sees. They notice the contours first, which are the interior of the shape, and don't define its place in the room. Then, maybe, the shadows, also a nondefining effect. By the time the beginner gets to the outline of the chair, the image is set in stone, and not always correctly. I want you to see that objects take up space. Form is something that happens to an object and to the space it occupies. An object is a dynamic thing even though is it stationary. It is an event in a designed area.

FINE-TUNING

You're having a tough time making a particular drawing work. We've all been there. You try it this way, then that way. After a day of attempts, you decide to sleep on it. The next morning, a mug of coffee in hand, you approach the artwork and take a fresh look. You can relax because there's no doubt anymore. You don't love it. You don't love it *a lot*. You can clearly see in the light of day every wrong approach you made yesterday. With a sense of humor, you dismiss the previous day's efforts.

As you go to toss it out, something puzzles you. Why can you so easily identify the problems today, but couldn't yesterday? Because yesterday you were trying to rescue your drawing from its mistakes. Today you're trying to rescue your *idea*. Perspective gives you a new lens with which to see. You have no wish to dig in and change things because it would be too extensive. Nonetheless, you make a half-hearted correction or two, and within minutes, you're all over it. Smoke is flying from your pencil and it's coming together. Sound familiar?

A beginner artist often sees their artwork as an extension of themselves and, therefore, makes decisions based on their preferences. But a drawing has its own needs, which do not always correspond to those of the artist who created it. For example, an artist might draw a castle exterior. Let's say it's supposed to look impressive, but for some reason it does not. The artist compensates by drawing elaborate gargoyles, but the castle still looks ordinary. Why? Because it needs to be drawn

in three-point perspective (an angle looking up at the edifice), which is amazingly easy to do and could make the castle look immense. But this artist doesn't like to use perspective. Now they've got a dilemma: draw what's comfortable or draw what the castle needs. If you're serious about your art, take the second route, even if it's a little bumpy.

Sometimes you do a bang-up job right from the start. Better than you expected. Feel good about it! You're allowed to admire your own work. But reserve a little something because when the dust settles, there's usually a bit more work to do. We'll explore that together.

EMOTIONAL SCANNING

When you insert a piece of paper into a scanner, the light from the scanner moves up and down the page—taking it all in—but the page never moves. A version of this type of scanning is used by artists and writers to identify where there might be problem areas. To do it successfully, you need to put yourself in an emotionally neutral state. You must not care where your human scanning device picks up areas of concern. You can't root for your favorite section to work.

Let's use writing as an example. Let's say that a writer has written five pages of a chapter. All the changes and corrections have been made. The writer expects it to be perfect and, in fact, finds nothing amiss. Before diving into the next chapter, she does this: she reads the five pages slowly, with no intention of looking for or finding problems. In fact, this method works only if you take off your writer's cap and enjoy the work you've written as a reader would. Read slowly from paragraph to paragraph, as if it were published and you were enjoying going through it in a bookstore.

Suddenly, the writer stops. Something feels wrong. She scans again, not looking to pinpoint a mistake but just rereading. There it is again. This will have to be addressed. She moves on, scanning back and forth over all five pages the same way, looking to sense even the smallest

blip that will interrupt the enjoyment of her writing. Sometimes a speed bump is positive, like a plot twist that feels right and works better than anticipated. Sometimes it's the absence of a positive feeling that gets your attention, like a passage that feels flat. The more you use this tool, the more accurate you can get with it.

That's for writing, but artwork is created as a single image (unless it's a graphic novel, storyboard, or a similar longform). Therefore, your illustration, painting, or sculpture may not give you the same feeling of continuity as you look it over back and forth. So, what does an artist do? They gain distance by using a different method. You want an impartial assessment of your work—even though you're the one assessing it.

Every serious artist switches hats in order to judge their own work. They typically do this by imagining that a viewer is looking at the work and what they might say. This is somewhat helpful, but neither role—the creator's or the viewer's—is impartial. The creator certainly likes the piece he created. If he thinks the viewer might not, he can always imagine a different viewer!

> **Every serious artist switches hats in order to judge their own work.**

It's time to bring in a third point of view: the Editorial Department. Remember them? You were first introduced on page 32. Editorial is interested only in whether the work meets the expectations of the intended viewer. That's it. Although we love the viewer's comments, they aren't so helpful. Those of the Editorial Department are.

In editing the piece, you want to know only whether your work is doing what you set out to do and to the extent you set out to do it. Is it effective? Does it hit a crescendo? Do you have a misplaced crescendo? Paradoxically, some editorial changes are hard to love but make the piece stronger.

MAKING CHOICES

Every line you draw creates a new choice.

In the movie *Apollo 13*, the one moment that stands out to me in this amazing film is Ed Harris's brief gesture at the end, as the space capsule suddenly appears in the clouds, informing the world that the astronauts are safe. Everyone at mission control cheers uproariously. Harris, who plays the flight director at NASA, does not; he sits down and pinches the bridge of the nose. I defy you to take your eyes off him during this scene. His was a brilliant choice, conveying so much emotion with such economy. I can see it in my mind as if it were playing right now.

The mind is like a menu. People usually select one of the first items they see, but sometimes the best ideas are not so obvious—like Ed Harris's choice. How are you going to be imaginative if you don't take a step or two off the beaten path and see what else is playing?

Let's apply this to the visual arts. Take an illustration of a sunset. Nice, but not unique. How could we make it dramatic? What choices would you make?

Big sun.

Okay, that's one idea.

Silhouetted people.

Another idea.

Half the sun cut off by silhouetted clouds.

An appealing approach. What else?

A blazing yellow sun in the middle of a pitch-black nighttime sky?

What? How did that last one get here? It's not an extension of the previous ideas or a variation, it's different and surreal. And it's *good*. I'll tell you how you got there. You were running out of ideas, so you took a crazy leap. What does that tell you? You're most creative when you're forced to stretch. Reach further, be inventive. You can always pare something down after you've sketched it. It's harder to pare something up.

You don't need to transform yourself as an artist in order to make a few bold choices. You could take a chance with one project but not with others. You could also switch to a different medium to do a daring project, which may leave your original style unaffected, thereby maintaining the followers you worked hard to cultivate and maintain.

> **You don't need to transform yourself as an artist in order to make a few bold choices.**

Some artists feel constricted by considerations about what the viewer may prefer. They may be unwilling to compromise their vision. These artists often reach further and take chances to establish themselves and their work. They may also be unsure that their work will find a home, but it doesn't have to be all or nothing. If you give the viewer a portion of what they're interested in, then it could serve as a lead-in to your more experimental ideas.

Less obvious choices can be used to emphasize the point of a scene. It sounds contradictory, but it's not. What is a less obvious choice? Hiding the point of a scene in order to create anticipation on the part of the viewer. Here's an instance where I used this technique: I wrote and illustrated a book called *Drawing Faeries: A Believer's Guide*. It was unusual in that it was half story and half art instruction. The introduction showed an artist at his drawing desk in the dead of winter, searching unsuccessfully for inspiration. He remembers having a feeling of wonder when he was a boy, but now it's gone. As

a child growing up in a small New England town, he had stumbled upon a kingdom of magical beings in the woods and they became his friends.

To regain his inspiration, he must find it again, but how? Having exhausted his other choices, he grabs his art supplies, puts on his coat, and trudges out into a blinding snowstorm. Hours later, half-frozen, and having all but given up . . . there, up ahead!

I drew the moment of discovery this way in order to cause the reader want to see it.

I thought about how to illustrate the moment of discovery. I did not reveal a kingdom or show the faeries. Instead, the reader sees the artist from behind as he drops his art supplies in stunned disbelief. I wanted the reader to *want* to see what the artist was seeing, rather than simply showing it. That sets up the next page where the story really begins.

You always have choices. You just have to look for them.

THE VALUE OF SKETCHING

Sketching is the freest form of drawing. It's expansive and extemporaneous in a way that can't be duplicated through other methods Sketching is invention. It is the act of searching and discovery. Imagine that. We're all prospectors now!

The dynamic and even misdirected lines of a sketch can lead to a deeper understanding of your subject and bring new vitality. It's fast and exciting. It's drawing in a hurry. Even the smudge marks from your pencil become incorporated into the picture.

Sketching has a unique advantage: you can sketch faster than you can criticize your own efforts! Sketches are often completed in as little as five minutes. "Gesture sketches," a type of sketch done of a human model, are commonly accomplished in one minute. A sketch or series of sketches can reveal a promising approach you hadn't thought of but may wish to consider. See past the scattered lines. Use your artist's eye to allow an image to emerge from the page. By restraining the natural impulse to flesh out the image with more lines, you're forced to capture a sketch's essence in just a few.

Fast sketching produces energetic images. (I can't tell you how many treats it took to get him to pose like that.)

If you continue to refine your sketch, you'll transition to a slower pace of drawing where you'll prune unwanted lines and bring others into focus. Though you may have been fond of your initial sketch, it likely needed to be adjusted. You may think a sketch is perfect as it is, and I understand that. Some of my favorite drawings were my sketches, but it's my finished work that ends up in my books.

DON'T THROW IT OUT!

I'll bet that on occasion you've crumpled up a drawing and, with a few choice words, tossed it into the trash can. But what about the other drawings? The ones that almost but don't quite work? What do you do with those?

File them. An artist's file is continually edited by reworking sketches from a new angle, including new sketches that aren't quite ready, and deleting unwanted work. In other words, it's a helpful resource for ideas, which *you* created.

Looking over past work, you can review your progress over time. Maybe your style has changed, or perhaps it has solidified and refined. You might also observe something interesting: that the style you worked so hard to develop was evident from the beginning. In other words, your style may have chosen you rather than you choosing it.

Sometimes an artist doesn't come into their own until they try a new style, and then suddenly—*pow!*—it all comes together. Don't be surprised to discover that although you've grown as an artist, you actually weren't half bad when you started. I see examples of aspiring artists' work all the time. They often have difficulty seeing how good they are. Sometimes they feel compelled to confess that they only draw as a hobby, but the word "hobby" describes what you think about what you do and doesn't describe the artwork itself. Therefore, a hobbyist with excellent skills is an excellent artist, not an excellent hobbyist. There are no two ways about it.

Sometimes artists save sketches that weren't drawn particularly well. What for? Well, they're not saving drawings, they're saving *ideas* for drawings. They're not married to the sketch. It's just a starting point, which provides enough information to get the ball rolling.

DRAWING IS REDRAWING

Most artists think of revisions as tightening up and fixing problem areas. What if you suddenly were to see an entirely new way of going forward? What do you do when your imagination suddenly pushes all the technical issues to one side and presents you with a new concept?

The natural reply is: "But what about the drawing I was working on?" That idea spawned a really cool, new idea and you came up with a better concept. How is that bad news?

A concept is a drawing *about* something. This can also be a revision, but it's a revision of the original idea, not necessarily the art.

Let's say you're drawing a classic knight and dragon. This is a concept we've all seen. What if you drew these two archetypal enemies so they appeared curious about each other? Perhaps the knight lowers his sword and the dragon offers his claw. Will the knight take it? Will there be peace throughout the kingdom? That is a concept revision.

Some people believe that techniques and feelings are at odds in creating art. Well, not so fast. Let's go back to our example of the castle that needs more *oomph*. The wider its base and narrower its top, the more oomph-iness it will have. In this way, technique is used to tweak an image to create more exaggeration. Emotional charge and technique work hand in hand.

In instances where the overall concept of your drawing is good, but lacks something, you can make effective changes based on the overall concept, rather than trying to increase technical accuracy. Look to

your storytelling abilities and push them. The key is to be *more*. More suspenseful. More expressive. More dynamic. More relatable. More fantastical. More contemporary. More visually jarring. And so on.

The key is to be *more*. More suspenseful. More expressive. More dynamic.

Bring new ideas to your revisions rather than only reworking old ones. Frequently, artists get into a rut by trying to *perfect* an idea rather than simply trying to *express* it.

Going back to our medieval theme, suppose we want to draw a hidden castle on top of a mountain in a Himalaya-type environment. But no matter how you draw it, the castle sticks out prominently. So you spend a few hours trying to cover it with trees, which camouflages it, but now the viewer can't see the castle.

What does a professional artist do in such a situation? Well, she doesn't keep drawing trees—I can tell you that—and she does not go for a walk on the beach. She goes to the refrigerator and looks around. She's not really looking. She's thinking, and she's trying to distract her mind with a change of scenery to give her imagination room to look past the points she's been stuck on for the past two hours.

And she's not just having thoughts, she's having a full-out dialogue with herself:

> *What am I going to do with that castle? I wonder if you can eat three-day old pizza? Maybe I should look it up. There was that movie about Mount Everest. Who's not going to be able to see a castle on the top of a mountain? Wait a minute. What if it's built into the side of the mountain? ? A gated door to make it subtle. But when it opens, there's an amazing castle inside! Yeah. And I think four days is about the limit for pizza. We're good.*

Here's another scenario that comes up when doing a revision. Maybe you had an idea you liked from an earlier draft, but ultimately decided not to use it. You still like it and—even though you have no new ideas for how to make it work—you decide to give it another try. Run for the hills! Save yourself! Red flags all over the place!

This is probably the easiest and most reliable way to take a viable drawing and return it to a previously unworkable sketch. Many artists have attempted this, including me. I'm not saying this cannot be done—artists are so darn good at finding new and creative ways to overcome obstacles—but be careful.

If the reason you didn't use an earlier idea is because you couldn't make it work, then—unless something has changed drastically to allow for its successful reintroduction—the problem may persist.

There's also a time element. When the idea was new, you probably had all the elements in your head, swirling around and interconnected. You knew why it wasn't working back then. Do you still remember the reasons? If you don't, you're likely to repeat many of them getting up to speed.

> You've got to follow your muse. If your muse is in a good mood, it may just work.

Of course, there are times when you just have to try, even though it may not be the wisest course of action. You're an artist. You've got to follow your muse. If your muse is in a good mood, it may just work. If not . . . just take its temperature first.

RELATIONSHIPS? WHAT RELATIONSHIPS?

For non-artists, the term "relationship" generally refers to the emotional bond between different people. For artists, it means something entirely different. It refers to the space and position between objects in a picture.

This positioning creates clarity, contrast, impact, and reference points. Each person, animal, or thing commands an area that works in relation to other areas. Some areas, like the space between people, can convey a sense of ease or tension. The point is that we're no longer thinking in terms of things that exist in isolation but which are in relationship to other things. In other words, the architecture of the space between things becomes an element of the picture.

Let's take a specific example. Suppose you've drawn a sketch for a page in a children's picture book. In this sketch there are supposed to be a dozen small toys on the floor next to a toy box. You aren't sure if there's going to be enough room for all the toys. As you proceed, you find that you need to draw smaller and smaller toys, hoping there will be enough room to fit them in. If there isn't, you'll have to erase all that painstaking detail.

There's an easier way.

By visualizing the toys as a single mass that occupies an area of the drawing, you can plot out room for a dozen individual toys. Begin by sketching a boundary for the pile of toys. This should include the height as well as the length and width. If you believe you have sufficient space, then you can begin your scene with confidence.

THE SPOT-CHECK

The spot-check is one of the last things on your list when finishing a drawing. It is a casual look at your work to make sure that in the myopia inherent in drawing, you haven't lost track of the big picture.

At its core, a drawing needs to agree with itself. If you've drawn a candy dish on a table, and then you draw a second candy dish of the same type, the closer candy dish would have to look slightly larger due to perspective. Therefore, they agree with each other and both conform to perspective.

Visual art exists within a logical framework. Even fantasy illustration has a logic to it. A drawing that contradicts itself asks a lot of the viewer. It requires them to overlook the problem in order to believe the rest of the premise of the drawing.

Visual art exists within a logical framework.

Let's say that an artist has drawn a person sitting lotus position on the floor. Perhaps it's a nice drawing that communicates serenity. Spot-checking, the artist notices that the knees are too close to the ground. That's not how people sit when cross-legged. The knees should rise up. Should the artist fix it? That's the question.

The fear among *all* artists is that once they open up the hood of the car and begin to tinker with the engine, something will be lost with the drawing. Here's my suggestion: give yourself ten minutes to absolutely refuse to change it. At the end of ten minutes, make the changes. While there's a cost to everything, what you might lose in spontaneity you may more than gain in effectiveness . . . and you won't have to wonder what someone is thinking when they look at your work.

After everything has been spot-checked, it's time to bring in the Contracting Department. (Yes, that part of your imagination again!) They go to work, tying all the elements together to create a cohesive picture. A little redrawing of this, some erasing of that, keep this area, and . . . done! Everything has led up to this moment: the sketches, the problems, the inspiration. There is a feeling of inevitability as you draw the final version. Put some music on as you bring it home. Enjoy yourself. You deserve it, you really do.

FOR BEST RESULTS, DRAW IN ORDER

Who says you have to draw in a specific order? Why can't you draw in any order you like? I once saw an artist who drew in the reverse order from how most art instructors teach, and her work was amazing. However, it was the only time I'd seen it done that way. It was like watching someone flip a coin that doesn't land on heads or tails but on its edge. It's cool, but not generally the way professional artists draw (or the way coins land).

Before you decide to go rebel on me, let's go through the stages of drawing that most professional artists use so you can make an educated decision as to whether you'd like to incorporate this sequencing into your work.

When beginning artists commence drawing, they generally draw with the intention that their first effort will be their final effort. No rough sketches, no erasing—just a pristine, final version. Who wouldn't like to have a drawing come out perfectly the first time? The problem is that drawings don't usually work like that. It would be like eating

You can be more creative and effective if you focus on the overall structure before diving into the details.

an entire pizza and the next morning the scale says you've lost five pounds. It's like a parallel universe occurrence.

Drawing with an eye toward making zero mistakes is a creative dead end. The energy spent on avoiding mistakes (safe thinking) must come from somewhere and most likely it will be diverted from creative thinking and exploration. If this is your goal, then you had better draw perfectly from the start because there's no room for error.

But what happens when you do make a mistake, which everybody does at some point? Let's see how that would work with the goal of creating a mistake-free first draft.

- Let's say our artist finishes a drawing on her first attempt. She spots a few mistakes that she really can't ignore and goes in to fix them. She's intent on keeping the problems localized.

- Most mistakes have tentacles that connect to other areas of the drawing. Our artist limits her corrections because she doesn't want to risk opening up the entire piece to revisions. Therefore, she works with small, surgeon-like strokes that allow for little in the way of creativity. Corrections are most effective when they exceed their original purpose and are done artistically.

- The patch job draws attention to itself because it has been reworked so often.

The bottom line is that our artist would probably have created a better drawing if she had started with a rough drawing and from that created a final drawing. That's just one reason to work from a rough drawing. The others are even more important.

With a rough draft you can erase things, draw over things, change things, and make a general mess. It's not meant to be the final drawing.

Once I erased part of a rough drawing so many times that I tore a hole in it. I taped another sheet of paper under it and kept drawing.

So, do we progress to the finished or final drawing from here? Sometimes, but not always. It depends how detailed the rough was. For example, a rough can be quite loose, sketchy, and smudgy—making it difficult to trace over accurately. Then you're in the same boat: trying to trace over something that won't cooperate. This is known as the "I can't believe I'm still drawing this thing!" syndrome. Relax, I'm going to show you how to avoid it, with an easy step called the "tight rough."

To me, the tight rough is the most enjoyable stage because you're still being creative, but you know you've got this. Here's how it works:

1. **Rough drawing:** Here you establish the concept with dynamic lines. It's messy and imprecise. So what? Just put it down on paper.

2. **Tight rough:** Create a new layer to trace over the previous drawing. Work out the technical problems and details, and improve the concept. There's still time to go for some spontaneity in poses, expressions, and layout.

3. **Final drawing:** Draw carefully and accurately. This is also called the clean-up stage.

A tight rough is not an absolutely necessary step, but if your first drawing (the rough) becomes cluttered and tough to make out, adding a tight rough after it could make sense for you.

WHEN YOUR CHARACTERS REFUSE TO LISTEN

Do you ever feel as if your characters have minds of their own? Would life be so much easier if they would just listen to you? We must be

kindred spirits. A character, unlike an inanimate object, wants to *be* something. You can feel it as you draw. Your pencil keeps veering off into uncharted waters despite your better judgment. You intend to draw a happy-go-lucky type but what keeps emerging is a shifty character. They can be so stubborn.

It can be a humbling to lose an argument with a two-dimensional drawing. We've got to find a way for you two to get along. Of course, the development of an original character is a give-and-take relationship. It's a continuous cycle where your ideas inform the character, and then the character informs your ideas. Where you both will end up continues to change as the character evolves. It's an incredibly organic process. There's no one really in charge, just the drive to create and to discover. Sometimes your characters will follow your direction. At other times, they'll be recalcitrant, mischievous rascals. Try to make it work. For the sake of humanity.

When you begin to draw an original character, you're looking for something to happen on the page. You may have had a preconceived notion, but the moment the pencil hits the paper, things change. It may take an interesting turn, but is that what you intended? Or are you in a creative tug of war with your own character? And so it goes, two entities dancing to the same tune, but each wanting to lead. This is how you get the best results, by the way. Your brain keeps squeezing out ideas, and your character takes them as mere suggestions. Back and forth. The head tells the hand what it wants to see, and the hand tells the head, try this instead.

The difficulty arises because this isn't the Creative You battling the Editorial You. This is the Creative You battling *another* Creative You in the form of a character. Don't expect the two to get along, even if together you produce good results.

The creative tug of war sounds something like this (if it sounds like anything):

YOU: *Maybe if I made the cheekbones wider . . . ?*

THE PENCIL: *In that case, I'll need something else to offset them.*

YOU: *How about sharp bangs, like this?*

THE PENCIL: *Bangs are good. I'll also change the hair length.*

YOU: *No! I like the hair length. Leave the hair length.*

THE PENCIL: *I changed it. Do you like it?*

YOU: *Maybe. But I really don't like it when you do that.*

This may, at first, sound like an inner monologue, but it's different. An inner monologue is a stream of consciousness. Here it's more focused. It's like a stream of argument.

What we have here is really a pushing and pulling that tests various ideas to see if they can withstand scrutiny. Consider your ideas from many angles rather than accepting them whole as they arrive. It's a creative experience, albeit in a tense sort of way, if that makes any sense.

Here are three basic steps for designing an original character:

1. Put something down. Anything to work with. Just break the inertia.

2. Sense a general direction.

3. Bring the concept together under one genre, pose, personality, or look. What overall impression do you want your character to make?

Let's widen this internal debate. Let's say an artist has sketched a scene with a charming house on a hill and a path with children running up to meet grandma and grandpa. But it doesn't *feel* charming. The artist is trying to figure out why. She vacillates between what she *wants* to feel and what she *does* feel. Don't be afraid to ask yourself the tough questions; they tend to reveal helpful answers if you're willing to hear them.

ARTIST: *It's charming. A house under a willow tree. How can it not be charming?*

SECOND THOUGHTS: *Why don't I love it? Maybe the problem isn't the house. Maybe it's the path leading to it.*

ARTIST: *It's a stone path. What could go wrong with a stone path?*

SECOND THOUGHTS: *That's it! That's the problem! The path goes up the hill to the house. The children are running up the grade, which looks like work. They need to run down to the house, with ease, and fall into their grandparents' arms. The house itself is fine.*

Now the artist can simply lower the grade of the path and the image will work.

> **Purpose is the fuel that pushes ruminative thoughts into the problem-solving mode.**

Overthinking gets a bad rap. Many creative problems could be solved if the artist would just think about them a little more. However, it's not just thinking, it's *purposeful thinking*. Purpose is the fuel that pushes ruminative thoughts into the problem-solving mode.

OCCAM'S PENCIL

Occam's razor is a principle, often cited in physics, that roughly says the simplest explanation is usually the correct one. Serendipitously, this applies to art as well. Like many things in life, nothing is true all of the time. However, you can make the case that simplicity is the solution to many problems in art. You can't make the reverse case, that complexity solves many issues. Therefore, *simplicity* is one of the first techniques to reach for when things bog down.

The Starry Night by Vincent van Gogh may be one of the most stirring paintings to have ever been painted. It appears complex . . . but is it? The village in which the scene is set has very little detail. The hills are painted with simple strokes. The towering cypress tree in the foreground is almost silhouetted.

What isn't simple about the painting is the cyclone of light stretching, bending, and twisting throughout the night and into the universe. Van Gogh did nothing to pull your attention away from the radiance of the heavens. Everything else has been left relatively simple and charming. You cannot help but look where he intends for you to look.

How do you use simplicity as a visual tool? By making one thing more important than another. You may love all of the elements in your drawing equally, but try to love one the most. It will simplify the design and create hierarchy for the eye.

You might think that your drawing, painting, or work of fiction is too involved, layered, or elaborate to be simplified, or that you have too much to say. Even in such cases, beginning with a simple sketch or layout could help to clarify your vision.

Persuasive illustrations are meant to provoke a response. Advertisements and promotional material are art with a purpose. They are created with a type of visual gravity that leads the viewer's eye to

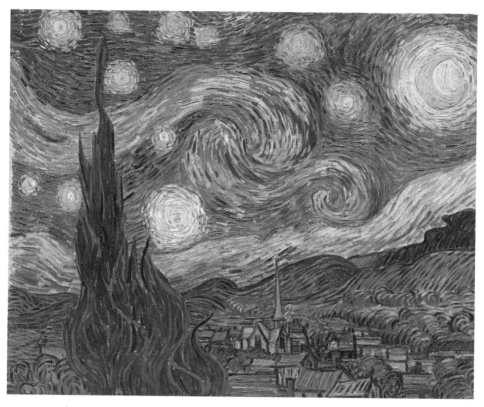

Simplicity, when paired with complexity, creates a dynamic contrast, as seen in Vincent van Gogh's The Starry Night.

the right place in the image without their being aware of it. Graphic designers are masters of this.

Being persuasive is not the sole province of commercial art; all art persuades. It makes you feel this or that or makes you think about something. This is not accidental. At the heart of this directionality is the principle of simplicity. A few examples:

- If you want the viewer to look over *there*, don't bog him down with an elaborate visual over *here*.

- If a character is not important to a scene, simplify it and leave the detailed treatment to the main character.

- The viewer will slow down at the more detailed areas of your drawing. Ask yourself if that's what you want.

- Strong images are generally simple. One person, alone against the horizon, could be more effective than a dozen people gathered together.

- The more things you try to say with your drawing, the less effective you will be in saying them.

Complexity isn't wrong if it works for you. In fact, some popular genres use complexity as the basis for the style, such as steampunk. Simplicity or complexity, it's all good. Choose what works for you.

The Aspiring
PROFESSIONAL
ARTIST

This chapter is designed to give you insights that could take your creative skills to the next level. It also addresses common issues artists face when they decide to sell their work or services, along with practical solutions to address them. Professional artists grapple with many of the same issues as aspiring artists, but they tend to handle them differently. Let's find out why.

WHAT'S IT LIKE TO BE A PROFESSIONAL ARTIST?

A youngster has a talent for baseball. He gets an athletic scholarship to college. He's drafted into the majors. The game he's playing in the majors does not at all resemble the game he played on the playgrounds of his youth. At the pro level, this is the only game there is and there's no going back. There's too much he knows. If he somehow magically returned to his childhood baseball diamond, he wouldn't throw like a kid even if he could. He would see differently from the other players. He would instinctively capitalize on opportunities no one else would be aware of.

What's on your résumé doesn't make you a professional artist; it's what's in your head and your heart. If you ratchet up your artistic skills, you will be playing a different game. It can be exciting, sometimes frustrating, but also immensely gratifying. And it may not be far from where you are now. Let's take a closer look.

THE LANGUAGE OF ART

The visual arts are a language. I'm not speaking metaphorically; it's a lexicon with its own terminology. When an experienced artist needs to solve a problem, they can identify the tool they need to use. For example, let's say our artist is drawing the human body and she's trying to figure out how long the torso should be. She turns to "proportions." According to standard proportions, the head and torso are roughly half the length of the human body as measured from the top of the head to the bottom of the hips. (There is often some leeway for style.) This is more accurate and takes less time than figuring it out by trial and error.

I've listed a few art terms and their definitions in everyday language so that they don't get too technical. You may be familiar with many of them, but it never hurts to review.

Hue: Any color type, for example, yellow.

Value: How light or dark a color is. Two different colors can have similar values.

Shade: It's a color that you add black to. Or a darker version of the same color.

Gray: Gray is added to bold colors to soften them. It's a super versatile and useful color. I don't necessarily think of gray as a color because it's not very colorful. But there are weirder definitions we live with, like that a tomato is a fruit.

Highlight: Any color that is lighter than the base color. This is often white, but it doesn't have to be. For example, a black bowling ball can have an orange highlight.

Contrast: The degree of difference between light and dark, usually when two things are positioned closely together.

Receding: When an object looks like it is traveling away from the viewer, toward the horizon. This is a term associated with perspective.

Advancing: The opposite of receding, the object looks to be coming toward the viewer, sometimes used to create a dynamic effect.

Framing: A design element that causes the viewer to see things within a controlled area.

Diffused light: Soft, evenly dispersed light, such as a horizon in the distance.

Hard or soft light: The brighter the light, the darker (harder) the shadow it will cast.

Contours: The curves and valleys of any surface, but most often associated with faces, figure drawing, and organic objects.

Proportions: Measurements of the head and figure by which the artist can judge the correct height, width, and placement of features within the face and on the body.

Flow: A line that easily melds with another line, or a single line that gently swerves back and forth.

Line quality: The thickness or thinness of a drawn line.

Special effects: Something that occurs out of the ordinary, often in fantasy or action genres, such as bursts of energy.

Transposition: Applying what is familiar to what is unfamiliar. For example, being able to identify where the elbow joint is on a dog.

Portrait/Landscape: These are the two basic orientations of a rectangular book, canvas, or sheet of paper with uneven dimensions. "Portrait" is taller than it is wide. "Landscape" is wider than it is tall.

Whether you work solo, on a team, or manage a team of artists, you will need to be able to communicate to other creatives. Terms such as these can smooth the way. Keep your ears open when you hear something new and log it in your vocab file.

IT'S ABOUT THE VIEWER

More than anything else, this one consideration—the viewer—is what separates the beginner from the more experienced artist. You can incorporate this lesson at any stage. By "viewer," I mean the person looking at your artwork. If the artwork is for a client, then the client will judge your work based on what they think the consumer (also a viewer) will like. The target of any piece is the viewer.

Every artist has their own sensibilities they want to express. But at some point, the professional artist will pause to assess whether what they have drawn produces the desired effect in the viewer. In other words, if the artist felt a sense of wonder while drawing something, he will ask himself if he has done enough to ensure that the viewer will experience that feeling, too.

Without an effective way to communicate your ideas to the viewer, art begins and ends with its creator. And that requires a certain degree of effectiveness, which is a good thing, and shouldn't be thought of as adding constraints onto creativity.

> **Without an effective way to communicate your ideas to the viewer, art begins and ends with its creator.**

Going back to our baseball example, I can imagine an artist reading this and asking a professional player if he wishes he could occasionally throw a ball without trying to doing it "right." To which, I imagine the ballplayer might respond, "You mean, do I ever want to throw *wrong*?"

A professional artist always considers how the viewer might react to what's going on in the page and instinctively creates a character, a pose, or an environment that is more likely to provoke a specific response.

Let's transpose this to illustrate the point. Let's say you're a clothing designer. A top manufacturer asks you to design a line of jackets. It's a great opportunity for you: high visibility, worldwide distribution, and good compensation. But what if the jackets the manufacturer wants you to design are not your taste? What do you do if you don't love it?

Treat it as if you do. Use the same tools.

Creative paradoxes show up in subtler ways, too, which are no less important to a project. For example, let's say you're drawing an advertisement for your local zoo. Many artists would select their favorite animal or the one they draw best. You could draw a bear cub or an anteater. Which would you choose? Neither is a good answer. The answer is that you first need to know if visitors to the zoo mostly come to see the cute animals or the odd-looking ones. With that information, you can bring your skills, originality, and resourcefulness to the process.

Here's another example that represents a common problem and the solution. Let's say you're drawing a person and it's important to highlight his smile. Once you finish, you look at it. It's a solid drawing, but wait; it's a full length shot, and you know what that means. It means the smile won't be prominent no matter how you've drawn it. The head is one seventh the length of the average person, which makes the smile a fraction of the image. The solution is to reframe the drawing as a shot from the chest up. Now the smile can stand out.

As a professional artist there are two people looking at your work all the time: you and the invisible viewer. Since the viewer isn't there to offer their comments, you must take on the role and think their thoughts for them. It's an essential part of conceptualizing a piece.

WHAT IS YOUR APPROACH?

Almost everything you draw could be enhanced if you began with an overall look that resonates. Descriptive adjectives serve as excellent starting points to introduce a subject and to breathe life into a concept. These are vital words. They can motivate you as an artist. You could use several words, but vacillating between them may offset their effectiveness. I recommend choosing one to be your North Star. Examples include:

Genre-based approaches:

- Dystopian
- Pop-fashion
- Holiday themes
- Action
- Romance
- Humor
- Juvenile
- Period pieces (e.g., westerns, medieval, etc.)
- Sci-fi/fantasy
- Panorama (open skies)
- Animals and anthropomorphics
- Crime/detective
- Horror
- Manga/anime
- Superhero
- Slice of life
- Buddy story

Emotional approaches:

- Cheerful
- Surprising
- Idyllic
- Tough
- Lonely
- Intense
- Carefree
- Intimate
- Adorable

- Mysterious
- Wistful
- Sophisticated
- Fantastical
- Adversarial
- Urgent
- Secretive
- Moody
- Courageous

You can always invent your own.

By marrying the genre to an emotional approach, you can often create something more compelling than either of the two modes by themselves, such as the hyphenated "manga-mystery."

WHAT IS A STYLE?

Style is a look. It isn't the form or foundation of a character, but it can change the appearance of a character so thoroughly that—in the eyes of the viewer—it's no longer the same. For example, a detective drawn in a hard, jagged style produces a very different experience for the viewer than the same detective drawn in an animated, retro style. Let's try another example. You can often find or develop a style within a style. In science fiction, for instance, you can choose several styles. There's dark sci-fi—where the future is grim and dystopian—or bright sci-fi—where the future is high-tech and hopeful.

Beginners are sometimes advised to wait to develop a style because you don't want to take a detour while still making progress on the basics. On the other hand, there have been many professional artists who used a style from the outset. They simply saw things through

a slightly different lens. Some successful artists have never drawn realistically. Their art is amusing, effective, touching, magical, and well-loved. Such artists are often self-starters who launched their own properties (characters, comics, books, licensed art, etc.) in a variety of media instead of working for a studio.

Absurdism is an engaging, odd style that often devolves into a search for the way back to home, and to normalcy.

A retro superhero look

For a style to be effective, it should be readily identifiable. An appealing style can get you where you want to go a little faster, but a style can also be limiting. Clients may assume your style encompasses the entirety of your skills. An artist with a distinctive style might not get a shot at projects that don't match up with their style.

One way to dip your toes into the water is to start with exaggeration. Almost by definition, using exaggeration means that you have decided to take an idea and re-create it less the way it *actually* looks, and more the way you would *like* it to look. So now you're drawing two styles at once: the underlying image in a way that people can recognize what it is (for instance, a suburban house), but then you're altering it so it becomes more of something else (by making it a weird house completely outfitted with advanced security systems and drones).

The exaggeration is more effective when it's applied consistently. If a person in a story is drawn in a flat, angular style, while others in the same story are drawn with an adorable, bouncy look, you might confuse the viewer—which you want to avoid.

Here is a list of some popular methods for arriving at a style. See if any of them appeals to you. Experiment. Developing a style can be fun.

Vary the proportions: This works for cartoon, fantasy, and adventure characters.

Exaggeration: Anything can be exaggerated. You just need to figure out what and by how much.

Under-exaggeration: This is a fun aspect of character design whereby you create humor by minimizing aspects of the character (such as a pet dog with extremely short legs).

Expressions: You can take this from wacky to intense.

Unique posture and gait: This is an effective way to unify a group of characters.

Outfits, fashions, and costumes: It doesn't take much for a character to stand out if they're wearing bold styles.

Dramatic use of angles or camera shots: Very popular in animated stories, comics, and gaming.

Roundness: If you want it to be adorable, make it round!

Flowing lines: These enhance the look of motion, and create appealing characters and scenes.

Delicate lines: Great for wistful or detailed art. It's popular with botanical renderings and fantasy.

Bold lines: This can work at opposite ends of the same pole—strong, tough, dramatic, or simple and juvenile.

Color themes: Cheerful, gloomy, spooky, monochromatic themes (e.g., inside of a volcano), and colors that represent an emotional state (green for feeling nauseous).

Color, front and center: Sometimes colors are designed to create a stronger image, compared to line art, in media such as picture books.

Bold use of light and shadow: These are used for comic book heroes and villains and crime noir.

The ability to draw in a variety of popular styles can provide security for an artist. This allows you to accept assignments from clients based on licensed characters or preexisting art. However, if you're passionate about one style in particular—your style—there may be an advantage to that as well. You could promote it with a singular focus, but be prepared: if you create a style and it becomes popular, you can expect others to imitate it.

One way to get started developing a style is to observe the things that stand out in your drawings. Perhaps it's oversized eyes. Or a

*The epitome of gothic horror: old and crumbling castle, with spikes,
a weathered façade, and a foreboding quarter moon in the sky*

sophisticated look. Or a look weighted toward one genre. Take those aspects and push them further.

Here's a common question among aspiring cartoonists and animators that touches on style. They see some really wacky, stylish, totally unrealistic characters on popular TV shows, and they ask, "Do I have to learn to draw realistically in order to draw characters like that?"

This baby dragon is cute because he has the checklist of cuteness: an oversized head, giant, glistening eyes, and a small mouth.

The experienced pro assures them, "Yes, little Suzy, Johnny, or Fido, drawing realistically will help you draw those insane characters."

Will it, though? I think the honest answer is, *not necessarily,* but it will make you a better overall artist. Should you want to work on something not-so-crazy-looking in the future, you will have the skills to do it.

RULES ARE MADE TO BE BROKEN— BUT NOT ALL OF THEM!

In art, rules are more like guiding principles. For example, you may learn in life drawing classes never to draw hands in pockets because people will assume you can't draw hands. The truth is a little more nuanced. While an art instructor might believe that figures with hands in pockets is an indication of compensation on the part of an artist, real people *do* put their hands in their pockets. That's one of the reasons for pockets. Therefore, strictly adhering to this convention may cause you to tie yourself into a knot to invent a weird pose that could be solved simply by sticking a hand in a pocket (as any normal person might).

Most guidelines are helpful. Some are less so. Others you may have developed for yourself from your own experiences, which are just as valid. Here are a few guidelines that have helped me. This is by no means an exhaustive list.

1. People like to see faces that smile.

2. A smile changes the shape of the eyes.

3. Profiles are all about the area from the tip of the nose to the tip of the chin.

4. Tough characters are drawn with small foreheads, small mouths, and big jaws.

5. If you shorten the torso and exaggerate the length of the legs, it adds style.

6. Action poses are more effective when slightly exaggerated.

7. Even in realistic scenes, clouds can be drawn as designs.

8. Big objects in the foreground can frame a composition.

9. If you want an indoor scene to look like it's closing in on you, draw receding lines in perspective from the corners of the ceiling.

10. A sloping line from the forehead to the snout of a dog makes it look cute.

11. Dogs have deep chests and indented tummies. Cats have larger tummies and narrow chests or rib cages.

12. The cuter the cat, the shorter the whiskers.

13. On a dog, the chest protrudes past the shoulder area.

14. The younger the dog or cat, the shorter the tail.

So, why create a drawing that goes against general art principles? To achieve a quirky look. Visual humor means more than drawing a wacky character. It can mean the creation of an absurd world.

Let's say you're a traditional type of artist who nonetheless wants to bring out more humor in your drawings. Where do you start? Here's a good place: draw the improbable. The improbable is funny because it's not the way we think things should go, so we already have the elements of surprise and irony working for us. It changes the rules of the game. Here are a few workable examples.

1. Exaggerate the look of characters by making them "very." Very gloomy. Very nervous. Very insecure. Very tired, etc.

2. Have animals mimic humans. If a dog owner is nearsighted and wears glasses, so might the dog.

3. Lose control of the action. For instance, a school kid might run, trip, and fall headfirst into someone else's lunch. You can't go wrong with school cafeteria humor.

4. This simple trick can alter the viewer's feel of the entire scene: draw a tilted horizon or add oddly geometric shadows. It makes everything seem kooky.

5. Caricature an object so it goes way beyond its intended look. For example, a potted plant turns into a jungle vine, which travels from the living room into the kitchen, where a small lemur is sitting on it.

6. Draw the family dog sitting at the breakfast table, reading the paper. Beside him, on the table, are the water bowl, dog food bowl, and his cellphone.

7. Draw the wrong sizes on purpose, like a family of four squeezed into a teeny car for a cross-country road trip. (Oh my god, I'd die.)

8. Modify perspective: the entranceway to an ominously tall haunted mansion, where a trick-or-treater can hardly reach the doorbell.

9. Break reality, such as a kid on his bike stuck to the ceiling.

10. Anthropomorphism (animals as people). For example, a dad character is pulled over by a cop on horseback, and the horse writes the dad a ticket.

Many concepts go through committees before being assigned to a freelance artist, in which case the company may not be expecting an artist to break new ground. Let's say you believe you have a cool idea, which would deviate from the assignment. You could ask the client for permission to work it up, but that could imply a negative judgment on the client's idea (because if you liked it, you wouldn't have suggested an alternative approach). No matter how bad you think their idea is, and I believe you, chances are your client loves it.

Strong genres require iconic elements. For example, if you want to illustrate a fairy, it's got to have elongated ears.

The safest route, within the context that nothing is completely safe, is to do it both ways. Present your version as something you came up with in a burst of inspiration on your own time along with the final product they asked for. But don't finish your personal approach. Leave it rough, as a concept. The client wants to feel that you spent more effort on their version—the one they are paying you to do, the one that you finished. On the other hand, if the manager of your project likes your idea, they may present it to everyone.

YES, I CAN DO THAT

There comes the time in many artists' careers when a client has an assignment for you. It's a good assignment that you want, but you don't know if you have what it takes to do a good job. This is a common problem. No one can advise you what to do, but it may be worth keeping in mind that the client thinks you can do it. Some people have a policy of saying yes and worrying later, but not everyone subscribes to that approach. I did when I was starting out; I found that on occasion I had to stretch. I also found that by doing so, I expanded my ability and created a new plateau at a higher level. You're dealing with that

age-old problem of not wanting to disappoint someone. Somewhere in there is a decision that's right for you and the client.

You might also get several offers from different clients. They might have different levels of complexity. That could inform you as to which offer to take.

Generally speaking, it's a good idea to take on as much work as you can early in your career. Here's why: as a newcomer, if you walk into a meeting and show a portfolio comprised of a dozen jobs you completed over the last eighteen months the client is going to be impressed. Especially when compared to someone who has only completed one or two.

Being busy is a good look.

COMMUNICATING WITH CLIENTS

Unsurprisingly, some clients don't understand artists and they don't know how to communicate effectively with them. This skill will have to fall to you. Clients basically have two things to say: *"This is what I want,"* or *"I don't want this."*

Sometimes an artist needs to see beyond the assignment but without changing it.

A client may not show much emotion about your work, but don't be surprised to hear that she has recommended you for another project and that one of her associates says that she thinks you're very talented. I know, it's weird.

Let's take a hypothetical situation. Yours may be different.

When a noncreative tells you their concept, it may not be fleshed out. Let's say the image requires a cowboy, a sheriff, horses, and a general store, but the client also emphatically says that this cannot be viewed as a western. The mandate is that this is an advertisement selling a modern western state as a tourist destination for Northeasterners.

Of course, it *is* a western because they just described a western.

Don't argue. Instead, ask questions. Be a problem solver. People generally like to answer questions when they believe the other person is trying to help. Challenging someone is a poor strategy. The client may begin to realize that your questions have merit but they're out of his wheelhouse. Things may begin to reverse so that as you discuss it further, the client is learning more about their idea from you.

I will include translations for those of you who don't speak "client."

> ARTIST: *So, you want to show some of the old with the new?*
>
> CLIENT: *Yes, exactly. But it can't be a western. Just modern horses and modern cowboys.*
>
> ARTIST: *I understand, but might horses with saddles and cowboys look western?*

(Saying, "I understand" to start the question neutralizes its pointedness.)

CLIENT: *What are you saying?*

(He's curious and he will listen because with a single question about a concept he's been working on for weeks, he's stumped.)

ARTIST: *I think we can say exactly what you're trying to say, and with the same elements, but in a way that is modern and, more importantly, gets the viewer's attention.*

CLIENT: *I'm listening.*

ARTIST: *Let's use your cowboys exactly as you envisioned them.*

(She's affirming his ideas as a way to lead into a new one.)

CLIENT: *Okay, good.*

ARTIST: *But instead of walking up to a general store on their horses, it's a contemporary clothing store and a high-end hotel. They might even have shopping bags with them.*

CLIENT: *So, what does that mean?*

(Humorless, but nonetheless intent on getting the idea.)

ARTIST: *It means that, yes, this is the West, and all that cool cowboy stuff, but while you're here on vacation, you can shop your heart out at the best stores.*

CLIENT: *(a long beat) Would you mind waiting here a second?*

(A long beat after a suggestion is often a very good sign.)

WEARING TWO HATS

Let's say you've finished a bunch of paintings of flowers for a boxed set of notecards that will be sold in museum gift shops. You need to cut one of the paintings because you painted eleven and the set only calls for ten cards. All of them are good; but one is great. It's a western scene of desert plants. Which do you cut?

As you look them over, you realize that the ten floral scenes work as a whole, but the desert plant is a real showpiece. Here are some thoughts that might kick around in your head as you decide which piece to pull:

- The desert plants took so much time create. I can't cut it.
- The desert scene shows off my talents the best; it stays.
- I love the desert one. I don't care if it's a little off topic, I have to go with my feelings. I'm keeping it.

I don't have to see the paintings to know that these considerations reflect a deep misunderstanding of the artist's relationship to his work. This artist is deciding which piece to save and which to jettison based on his relationship to each individual piece rather than to the project as a whole: a set of notecards based on a theme.

As an artist, the moment you finish a piece, you should judge it as if it has been created by someone else. Although there could be exceptions, no allegiance should be given to a favorite piece and no amount of toil in its creation should be considered. You must be willing to throw out your best work if the project will suffer from its inclusion. I have files of original work that have never been published because they ultimately didn't work in the context of the project.

Some of this work is wonderful but I'm not making a portfolio. I'm illustrating a book and it has to work on many levels.

Problems with gorgeous pieces that do not work in the context of a larger project can include:

- They might not effectively lead from one page or subject to the next.

- The subject makes the viewer wonder why it's there.

- It looks like a one-off, whereas the rest of the art looks like variations on a theme.

- The medium is different. For example, everything is in acrylic but one drawing is in charcoal.

- It looks as if it were created by a different artist. Versatility may be an asset, but not when you are trying to create a cohesive look.

An artist must think like their own adviser. You must love the project more than the individual pieces that make it up.

SUBMISSIONS AND REJECTIONS

There are two types of writers in this world: those who submit their work and those who don't. My advice is likely to be different from what you would hear in some writer critique groups. I'm going to assume that you have written a manuscript, or finished an illustrated proposal, with the intention of getting it published and that you want to send it out. Therefore, I'm going to take your intention seriously and respectfully. This is not about you feeling good about your writing, it's about how to get published. I want your manuscript out there and I want it considered for publication. Unless you can let go of it, it can't get published.

> There are two types of writers in this world: those who submit their work and those who don't.

Working to overcoming feelings of inadequacy before you submit your work is not a good strategy. People put their dreams on hold for a long time—sometimes forever—with that strategy. Some of them relieve their angst by performing serial extensive rewrites, whether their manuscript needs it or not, because it feels safe and familiar. That's another way of keeping a bear hug around their manuscript.

So go get a suit of armor and let's slay this dragon together.

You cannot avoid rejection and be a professional writer (or artist) at the same time. Rolling with the punches is not only a good approach, it's the only approach. If you receive a rejection, don't assume your work is no good or, in the other direction, that your work is perfect and anyone who rejects it knows nothing. Having perspective is key.

There are two simple steps for submitting your work:

1. Research the places you'd like to submit it to. Find out what they require, in what format, and to whom to send it.

2. Send it out.

Please understand, I am not suggesting you must send out your work. You're no less of a person if you decide to put your manuscript in the drawer and think things over. But if you've decided to take the bold leap forward, then it's time to research agents and publishers.

Suppose you're having second thoughts about whether your work is ready to submit. Maybe it could be better. But chances are that it could always be better. A more useful self-assessment could be, is it ready?

If you do submit your work, you're probably wondering whether you'll get a rejection letter. Let me make it clear: it's almost a hundred percent certain. I've gotten them. We've all gotten them. Welcome to the club.

Ultimately, you need to put rejection in the rearview mirror, where it belongs. You may not be over the sting, but if you need to feel completely restored before you can resume your submissions, then rejection has you hostage. Would you like to know how the pros handle rejection? They go "Ouch!" and get back to work. There's only one direction: forward.

There are generally four responses you can expect to receive from a submission:

- You don't get a response.

- They don't love it.

- It's not for them, but they give you some suggestions.

- They love it.

If you can live with any of those things happening, you'll survive and live to submit another day. Here's something to consider: who is more successful, a writer who sold their manuscript after receiving twenty-five rejections, or a writer who sold their manuscript after having received only three? They're exactly the same. Once they're published, the slate of prior rejections is wiped clean and it's all about the sales of their new books.

NEVER WORK FOR FREE

You can make any decision about your art and career that you want. You have agency; no one can tell you what to do. I can only offer my best advice and my opinions. Given that, here is one: never work for free. Some artists just starting out are asked to work for free. A job offer comes with money. I don't know anyone who has benefited from working for free. I don't know anyone who has said, "If only I had done more free work." I could be wrong, and you could be the first, but I recommend letting somebody else try that approach. You ask for money.

Some people have no compunction about asking an artist to do a drawing for free that they plan to monetize or that will save them the expense of hiring an artist. Perhaps you believe an opportunity has come along that is so compelling you want to subsidize the company behind it. Have I got that right? It doesn't sound so good when I put it that way, does it? Here are some things they might say, which gush with irony:

- We view this more as a collaboration.

- Once this project gets going, there will be a lot more work.

- We don't think you should miss this opportunity.

- It will be great publicity for you.

- The owner of the company is a big fan of your work.

- We'd hate to lose you. I think we're building a very good working relationship.

Working on a no-pay job takes as much time and effort as working on a project you do get paid for.

Working "on spec" is not the same as working for free. "Spec" is short for "speculation." It's when you've developed a property—a picture book, for example, but it could be many things—and you hope to sell it. If a company doesn't buy it, you still own that content and can take it elsewhere, provided you didn't sign an agreement with the company that would prevent it.

ARTISTS, WRITERS, AND DEADLINES

I find deadlines useful; they're like a personal trainer urging you to keep going. Many people hate them. The deadline looms over their heads, fomenting anxiety and slowing their progress, which makes them even more anxious. However, if you thought this was going to

be a tough problem to solve, you're going to be disappointed. It's pretty simple and works when other approaches may not. It requires a willingness to embrace the fact that, as a professional artist, deadlines are going to be part of your life.

To make a deadline, you have to back into it. If you're a children's book illustrator, pages are a natural metric for keeping count of your progress. If you're a photographer, you could substitute the number of images instead. It's easy to transpose this to your own medium. Next, you have to budget your time. If you have a project that comes due in four weeks and requires four finished pages or images, that means you have to produce one finished page or image each week. You might also want a few days at the end to review your work and make any last changes. You would have to calculate for that, too.

The least reliable approach is to start a project with only a vague hope you'll be able to finish on time. Know where you are at every point in a project. Revisit your schedule periodically because some aspects of your work may require more time than you anticipated. If that happens, adjust. That brings us to the Big Misconception:

Writers are expected to be late.

This is such a commonly held belief that it could be a meme, but it is wrong. When a publisher or client gives you a delivery date, they want the work by that date. They really do, and if you tell them you can make the deadline, they expect that you will. The client needs you to deliver by a certain date because he has to deliver it to someone else. If you're late, he's late. Part of building a relationship with a client is being reliable. Clients like to work with people who don't give them headaches.

Some believe that deadlines create too much pressure. This reminds me of a writers' strike in Hollywood some years ago. The writers I

knew were looking forward to using the time off to write their own screenplays without being under the yoke of the studio system. When the strike ended, guess what? Not one person had written a screenplay! They needed the pressure of a deadline to motivate them.

Some people get a writing partner as a solution to deadlines. Sounds good. But there is always the possibility that your writing partner is slower than you are. Or that someone's day job suddenly requires all of their time. Of course, sometimes delays are due to creative differences. One of the most reliable ways to make a deadline is to rough out or outline your piece before you start. Working out creative problems in advance helps you avoid getting stuck in unproductive ruts, while maintaining your view of the road ahead.

COMMERCIALISM AND ART

Some artists believe that selling one's art is corrupting. They believe that one's integrity cannot sustain itself where money is involved, but money has always been involved in art. The giants of the Renaissance—Raphael, Michelangelo, Titian—worked for the aristocracy, kings and queens, and the Roman Catholic Church. They were the commercial artists of their day.

Commercial art is art. It often pushes the envelope and explores the newest media. If you feel the need to guard the integrity of your art by removing the profit motive, that is your right. However, let me challenge it a bit. Perhaps you may be able to accomplish both things: integrity and success.

One of the biggest fears artists have about selling their work is that success will pull them in an unanticipated direction. First of all, what's wrong with that? Unanticipated directions

Unanticipated directions make life interesting for artists and even more interesting for viewers.

make life interesting for artists and even more interesting for viewers. This could bring you in touch with more people in your field, which in turn could make you more creative.

Let's say that doesn't work for you—you really want to paint woodland scenes in winter. I hope you do—I love woodland scenes—but this may be an opportunity to have your cake and eat it, too. Let's say you have clients for your art, which is of a commercial nature. You could view it as a way to subsidize your fine art. Then you would have commercial art in your work life, but fine art in your personal life. These are called personal projects and many artists have them, show them, and sell them. An artist never needs to adjust their personal art to suit the tastes of others, unless they want to.

There's one more thing to consider. Many fine artists became popular during their lifetimes, which did not inhibit their creativity. Picasso dominated the world of art in the twentieth century. His continuously evolving style led rather than followed the market. Imagine the gaping hole that would have been left in the art world had he resisted selling his work.

You might be concerned that, as a commercial artist, working for a client turns them into a quasi-collaborator, giving them a say over your project and decisions. That's exactly what happens, but that can happen anytime you work for someone. You could be an architect and have designed the best home, but if your client wants the pool in the front yard, you're putting the pool in the front yard. However, if they had enough good taste to hire you, then hopefully they have enough good taste to take intelligent suggestions.

This reminds me of a film class I took in college. The students were talking down the popular films (action movies, sci-fi, you name it). The students wanted to make "art." The instructor listened to all of this, then pointed out that these "commercial" films were the same films that inspired them to go into film in the first place.

If you're having a conversation on this topic, someone will doubtless bring up Vincent van Gogh as an example of an artist who did not compromise his ideals. It's a painful example. If Van Gogh could have had one wish, I imagine it would have been to have had a profitable relationship with a gallery so he wouldn't have had to continually ask his brother, Theo, for money.

Maybe you think that having a gallery represent your work could shield you from market forces. After all, you would paint whatever you wanted to paint, and the gallery would show it and sell it. But nothing is that pure. If a gallery owner is showing bucolic scenes that are selling, and you're a painter of city scenes, he will ask you if you have any rural landscapes. He's got rent to pay, too.

Commercial art has the potential to reach far more people than ever before due to media and technology. But technology also works for fine artists. So, what would you like to do?

WHAT IS YOUR BRAND?

The term "brand" is overused but it is not without usefulness. A brand, simply put, is the way viewers describe you and your work to others. An artist's brand could be an approach that speaks to a certain segment of the population, such as young adults. It could also be an artistic style, such as realism. It could be about the type of artist you are to work with, such as one who gets the concept, works hard, and delivers on time. No matter what level you find yourself at today, you are evolving into your own brand. You can help yourself by doing it effectively.

You're never too young or too old to get started. An aspiring artist who cares about details is cultivating a brand. Likewise, an artist who consistently looks for inventive ways to express her vision is crafting a brand, even though she might not know it. Artists who exhibit at shows based on a theme are cementing their brand to that theme.

When my art instruction books were taking off, I was having lunch with the owner of an advertising agency that specialized in books. We were discussing my work and he said, "Chris, you may not like this, but you're a brand." He said that when the sales force asked my publisher for the next "Chris Hart" book, they weren't thinking of me as an author, but as a brand or line of books, a product—and that the same held true for retailers and distributors. Well, I've been called worse.

In developing your own brand, know where you want to go and how you want to be thought of. Here are a few positive associations that can be developed into a brand:

1. Style
2. Genre
3. A demographic or region
4. Clever, offbeat ideas
5. A team leader; can helm a project
6. Detail-oriented
7. Wears many hats: draws, writes, and designs
8. Can mimic other styles
9. Knows what's new and what's trending
10. Has many followers on social media

You can extend this list as far as you like.

Here's a twist on developing a brand: let's suppose an artist likes to draw comic book heroes but doesn't like drawing backgrounds (most likely because the artist struggles with them). This is holding him back professionally and limiting his opportunities. He takes an art course, buys a few books to help him draw backgrounds, and he practices.

As a result, he begins to get positive comments on his backgrounds and environments. People seek him out for it, but he knows—in his heart—it's not his thing. Well, I've got news for this artist: it's your thing now. It's not unusual for an artist to work at patching up a weak area only to improve to the point where they've overshadowed their strong area. Life is odd. You've got to roll with it.

Many manga artists protect their brand instinctively by carving out an identity. They tend to stay in their own lane as either a digital artist (drawing on a tablet) or a traditional artist (drawing on paper). These artists are therefore branding themselves two ways: by subject and by media.

WHAT A BRAND DOES NOT DO FOR YOU

Here's a popular misconception about success and the arts: *Once you're popular, people will buy your art because your name is on it.*

The anime style of drawing has become closely associated with my work.

This type of thinking reveals a wish: if you're successful, you won't have to work that hard. Your name will do it for you. Let's say you've come up with a line of books on sci-fi art. They're selling like crazy. Guess what happens next year?

Other publishers launch dozens of books on sci-fi art. You're suddenly drowning in imitators. Consumers may still recognize your name. And because of that, they'll pick your new book up and flip through

it, which is an advantage. But because of the increased competition, what's between the covers has got to be better.

This reminds me of something earlier in my career, when I introduced a series of successful manga how-to-draw books. Other publishers soon introduced theirs. Every season, more competition entered the ring. I noticed that these other publishers were coming out with manga books on topics that were narrow, in order to find new material. I went into my publisher's office and said that everyone is out on a limb doing topics that are too specialized. I wanted to go in the other direction. And I did, and it became a new series.

The takeaway is this. A name gets your artwork a look from the consumer, which is a real advantage. But after that, it's all about the material.

CHAPTER 7

POPULAR WISDOM *to* Reconsider

People love to give advice. For some reason,
aspiring artists receive a lot of it. It's hard to give
a biologist advice, but art? People have lots of
suggestions. Some good, some bad, some very
bad. You can take any advice you like. I'm going
to give you advice that may be different from
what you've been hearing.

Artists who are starting out are often exposed to advice that has a ring of truth to it, but may not be effective in practice—or even deleterious. Just like advice found in critique groups, take with a grain of salt advice about art or writing from people who are not professional artists or writers.

Art comes from the heart, not the head

What do people mean when they say you should draw from the heart and not the head? I believe they're in favor of allowing their feelings to lead the creative process. And that's fine. But there is an implicit judgment that the head, typified by thoughts, is somehow deleterious, and by getting lost in your thoughts, your artwork will suffer. This is tying one hand behind your back. Some of the most amazing works of art have been created as conceptual pieces and books, which required a combination of an analytical eye, the imagination, and feelings. Don't renounce essential aspects of creativity for a poetic but impractical idea.

If you can imagine it, you can create it

Let's see how this could work. You sit down to draw something that you can picture in your mind. But it's not coming. What happened to the saying? Maybe there's a reason you're having trouble with an idea. Have you considered that it might not be the right one? Often, we stay with something we believe we should be able to draw rather than widen our vision to create choices that solve our problem. Don't be fixated. Be nimble.

There is no right way to draw

There are many successful artists who have a distinctive style that doesn't require accuracy. These styles—whether primitive, exaggerated, or dynamic—are generally consistent within themselves. The omissions in their art are purposeful, and therefore not mistakes. What you don't want to do is overlook errors that can distract an audience. The viewer may have no idea what's wrong with a picture but will find it somehow uninvolving or awkward. So while there may be no right way to draw, there are many wrong ways. Try to avoid them.

You have to be born an artist

The predisposition to be a visual artist may be encoded in a person's DNA, but the visual arts are stratified and specific. For an artist's talent to be genetically determined, there would have to be a cartoon gene, a photography gene, a crafting gene, an ice sculpting gene, a gene for people whose favorite color is chartreuse, and so on.

Even if there were a deterministic factor that makes people what they are, my reaction would be the same: so what? Being predisposed guarantees nothing. It doesn't turn you into something or prevent you from becoming something else. People with and without an innate sense of art need to contribute to their success. The habits and mindsets of successful artists can be possessed and acquired by anyone who works to develop several key qualities. There may be more, but here is a good starting place:

1. A passion for drawing

2. A routine of drawing often

3. A willingness to consider many options to solve a single problem

Do what you love and the money will follow

This is actually terrible advice: there are thousands of aspiring actors in Los Angeles who are following their dreams and the vast majority of them are unemployed. Better advice would be: "Don't do what you love; love what you do well." I'm not suggesting you break up with your first true love and find a practical alternative. Only that you let a little light into your choices and find a happy place where you can both shine and be who you are.

Try to get it right on the first try

Do you know which type of artist makes the most false starts when they draw? A professional one. They don't expect to get it right on the first try. That's why most of their energy is focused first on roughing

out numerous sketches, whereas beginners focus on finished drawings. Getting it right on the first try is of no consequence; it gets you nothing except the feeling of accomplishment you might get from pulling off a magic trick. You could draw a perfect version on your first attempt or on the twentieth. The only version that counts is the last one. That is what the viewer sees.

It's okay to leave it the way it is; no one will notice

This is a tough one because the saying is meant to be supportive of the artist, but it supports them in exactly the wrong way. It means to spare the artist effort when extra effort is exactly what is required. Your art may look fine at first glance. The viewer may never notice that something is wrong with the image, but if *you* notice it, then there's something wrong.

It's like having a contractor work on your house and install a bookcase that's slightly crooked. You can hope that no one will notice, but hoping is not an art technique. Is it possible that no one else will notice? No, it is not, because *you* noticed; the little error you decided to overlook will haunt you for the rest of time and beyond. It's just not a good ethos to incorporate into your work habits.

Everybody makes mistakes, and if yours show up after it's been published, well, that's life. Allowing an error to remain in your work before you even complete it is another thing entirely.

I remember a time I delivered a book to a publisher's office, and as I was guiding the editor through it, I saw a problem with the flow of the chapters. The editor liked it and approved it as delivered. Nonetheless, I asked for two weeks to turn it around—which I received. I delivered the revised version as promised and it became a solid-selling edition in one of my series. I can't know for certain if it wouldn't have done as well without the changes, but I believe the changes enhanced the readers' experience.

Save your best work for yourself

This way of thinking reveals an antipathy some writers and artists have for their clients. Some believe it's almost de rigueur, as if you're not a real artist unless you dislike your employers. Let's take a look at this self-destructive attitude. It can have unanticipated consequences if a client comes to realize that your personal work, which you sell and post, is superior to the work they paid you to do.

Remember this truism: clients don't like to work with people who dislike them.

Talent is in the eye of the beholder

Were that true, no one would be able to spot talent because no two people could agree on what it was. Talent is not what clients are looking for; they're looking for art. They evaluate the art on whether it's engaging and will reach the intended audience. It's always about the work.

You can't make an error when it comes to art

This slogan is for people who want to do a victory lap around drawings that are crying out for corrections. Beginners deserve encouragement, but they also deserve honesty—respectfully offered, and only when they're looking for it. It's best to offer help in the form of tips and suggestions—which keeps it positive—rather than a critique—which is, by definition, negative.

Draw from observation

Have you heard this one? Many people subscribe to it. It goes like this: leave your preconceptions at the door and draw only what you observe from the model. Don't impose or project anything onto the form.

While this makes sense conceptually, it puts the imagination in the back seat, where it doesn't belong. What happens when you don't have a model to draw from? Or if you want to draw a different pose? Popular art requires exaggeration, style, and inventiveness. There's a daring

quality to art that's lost when you copy the model as if it were a statue. I was once in a life drawing class where the instructor laid out a grid for us to draw from. How can you bring life to the figure under such circumstances?

Therefore, I think this saying should be amended:

> *Draw from observation to learn, but draw from the imagination to create.*

It's all about the process

This slogan makes me cringe. I hate it so very much. The *process*, as I see it, is when a writer's output of work is inversely proportional to their involvement in a critique—or writers'—group. There are valuable things that can be gotten from such groups, including a feeling of comradery. Some groups also invite guest speakers, have meet and greets, and offer prompts to write from.

Groups that encourage endless talk from members who show no interest in actually writing are flawed. These members sometimes

To create varieties from a single pose, you need to be able to draw from the imagination, not just from observation.

soak up a lot of everyone's time talking about what they're going to write but they never *actually* write. Meanwhile, those who have brought their work to read to the meeting often fade back into their chairs. Beginners are insecure about standing up for their work; their participation needs to be elicited.

I've known many professional writers, from friends to family members to friends of family members. Professional writers like to get together and complain about their agents, but talk about the *process?* Get out of here. No one talked about it. Talking a lot about your work-in-progress is not an activity that necessarily leads to being a writer.

Some writing groups offer prompts on subjects that have nothing to do with the projects the members are working on outside of the group. It's a curious idea: spending time writing on random subjects while you have a book to finish.

There are several reasons why people find writers' groups valuable, and other reasons why some languish in them:

- It's a safe place and there's no fear of rejection.
- You find support from like-minded people.
- Some writers believe they have only one book in them and—by never completing it—they won't have to give up the idea of writing.
- They get to speak at length about their book without actually starting it.
- The leader of the group seems knowledgeable.

Nothing teaches you more about writing than submitting your work and having it accepted or rejected. Rejection can sting, but some

agents and editors can be kind and encouraging with their comments, even when responding to blind submissions (unsolicited proposals).

Consider this: if you believe your project has value, do you want to delay the chance to introduce it to the public? Are you going to wait so long that someone else thinks of your idea and executes it first? We're all going to face rejection. If you want to join the ranks of professional writers, finish your work, submit it, and begin your next project. I judge the seriousness of an aspiring writer by how many times they have faced rejection and continued. That's grit, and grit helps.

My final advice on this: don't fall in love with the process. It's the road to nowhere. Finishing is the most important part of starting.

There are a number of established associations for writers and artists. I recommend looking them up to see what they have to offer, including whether they have local chapters near you with in-person or online meetings. Here are a few:

- The Authors Guild

- Society of Children's Book Writers and Illustrators (SCBWI)

- Writers Guild of America (West & East)

- Graphic Artists Guild

- Society of Illustrators

- National Cartoonists Society

- ASIFA-Hollywood (International Animated Film Society)

You don't need an idea—just draw
Just draw what?

Go with the flow

This is a tricky one. Everyone likes flow, but flow implies a series of undulating twists and turns. When you're flowing, you're letting your pencil do its own thing. To make a scene work or a figure or character, you have to make sure you've covered all of the bases, whether they are in the flow or out of the flow. Let's see what happens when your own judgment takes a backseat to the pleasurable sensation of drawing a flowing line.

Let's say you've decided to paint a day at the beach for your local art show: people playing sports, families enjoying the sand and surf, etc. Far off in the background, there's a roller coaster. Maybe you've never been good at drawing structures, but today you're flowing and that roller coaster is coming together in extraordinary detail. It's a great looking roller coaster, and you nailed it. Congratulations, you've just painted an advertisement for an amusement park ... but you wanted to create a day at the beach, what went wrong?

You flowed too much! The roller coaster, being in the background, should have less detail than the beach and beachgoers in the foreground. Going with your impulses made you less—not more—effective.

Flow and spontaneity are great, but they work best if they are bracketed within bookends, and those bookends represent the premise. I recall wanting to write a book for kids about how to draw animals. At a hefty 180 pages, you can get detoured quickly if you're not careful. I needed an anchor for my idea. I kicked around various approaches, and then I realized that this wasn't going to be a book about how to draw. This was going to be about having fun with art while learning to draw, and animals were the subject. That was all I needed.

Utilizing that premise, every drawing became fun and exuberant. The poses, attitudes, and character designs were fun. The art instruction gave the young reader just enough pointers so they could have fun

recreating the animal characters. *Drawing Animals Shape by Shape* remains one of my most popular books.

Everyone likes my drawings

That may be true, however, not all compliments are equal. Some are very not equal. It's great to get the support of your family but their affection for you might influence their judgment. When your grandmother tells you that you just drew the best manga she's ever seen, thank her but take it with a grain of salt.

Cute-with-attitude. A winning combo for cartoon animals.

For feedback you can use, get your work in front of a professional artist. There are a zillion art-related conventions across the country each year. Walk the floor. Talk to the artists at their booths. Say hello. They are there to meet people just like you.

Art is whatever you say it is

This is about as true as the saying that exercise suppresses your appetite. Let's start with modern art. Some people hold the opinion that art is anything you want it to be. You might believe this definition, and you're entitled to it, of course, but if you bring your child to a museum with a modern art section, what are they likely to say?

CHILD: *I could have drawn that!*

You may be likely to respond this way:

"Darling, it takes great skill to put the nose on top of the eyes."

But your kid isn't all that far off. Check the drawings under the refrigerator magnets at home. Generally speaking, people who believe in this are referring to conventional, rather than abstract, art. I believe this is said in an effort to defend all art from criticism. There are probably good intentions behind the impulse, such as encouraging people to be creative. If that's the case, perhaps anything can be art, but not everything can be good art.

If you think man's inhumanity to man can be expressed by dripping paint on a slice of toast, okay by me. But first, let me float a non-insane definition past you. See if it has the ring of truth to it: what makes something art is a tacit agreement among viewers that it has a level of aesthetic quality or effectiveness.

That's why it's tough to call painted toast art. No matter how well you paint your toast, I would remain unimpressed by its quality—even if it was really good toast. Likewise, you and I may not agree whether we like a portrait of a man, but we could still agree that it is art.

Commercial art is something entirely different. It usually has to be appealing or provocative, and effective. It needs to set out to do something and it has to accomplish it.

Be in the moment
Philosophically, this may be an appealing notion, but does it work? Should you prevent your imagination from wandering offtrack? Don't all creative thoughts go offtrack? One would hope so. But according to this way of thinking, as soon as your mind starts to drift, you're out of the moment, and you've got to get back in.

Adherents to the be-in-the-moment credo might counter by saying that whatever you're thinking at that moment is part of the moment. But that renders the saying meaningless. If my mind can wander anywhere and still be in the moment, then what are we talking about? It seems to me that this saying is really about using art as a route

to personal mastery, which is fine, but has a somewhat tenuous relationship to creativity. Ultimately, it doesn't matter whether you're in the moment, or thinking about what to have for lunch, so long as you're pleased with the outcome of your efforts, and the pizza has the topping you like.

ALL THAT YOU NEED, YOU ALREADY HAVE

We've traversed many areas of your fertile imagination together. It is wide, it is deep, and it offers limitless possibilities. The road ahead is not always clear for creative types, but therein lies the excitement of the journey. Do you have a passion to draw? Can you see it in your mind's eye? Are there things you'd like to draw and write? Then you have it all. And if, along the way, the road becomes unclear, just envision it as it should be and you will see it, up ahead, in the clearing.

Your colleague in art,

Christopher Hart

INDEX

(Note: Page numbers in italics indicate images.)

absurdism, *120*
advice, responses to, 145–156
agents, 82
animation, 82–83
Apollo 13 (film), 94
art
 defining, 154–155
 emotion-based approaches, 119
 general principles, 126–127
 genre-based approaches, 118–119
 terminology, 114–116
 types of, 29–30, 110–111
artists
 aspiring professionals, 62–63
 beginners, 60–61, 120
 developing, 61–62
 feedback from professionals, 77–78, 154
 how to know you are one, 19–20
 imagination of, 21–23, 32–33
 qualities of successful, 147
 reaching for the next level, 63–64
 as their own advisors, 133–134
 as those rediscovering passion for the arts, 63
art reps, 82

beginners, 60–61, 120
be-in-the-moment credo, 155–156
boredom, dealing with, 74
brand development, 141–144

careers
 animation, 82–83
 children's picture books, 80–82
 comic/web strips, 86–87
 graphic novels, 83–86
 greeting cards, 87
 options to explore, 88

characters
 comic strips, 87
 designing, 84–86, 108
 developing, 50–54, 107
 style and, 119–125
children's picture books, 18, 49, 53, 80–82, 102
choices, making, 70–72, 94–96
clients
 accepting assignments from, 129–130
 communicating with, 130–132
 judging your work for, 133–134
comic strips, 86–87
commercial art, 110–111, 139–140, 155
communication, 64, 130–132
complexity, 112
concepts
 approaches to, 118–119
 bringing into focus, 54–56
 communicating with clients about, 130–132
 vs. ideas, 26
 keeping the viewer in mind, 116–118
 revisions as, 99–101
concept sketches, 68–69, *69*, 129
contours, 115
Contracting Department, 18, 32, 39–40, 103
contrast, 115
corrections, 64
creative process, 37–41
creativity, 33, 41, 70
curiosity, 64

deadlines, 137–139
diffused light, 115
Disney, Walt, 50
Drawing Faeries (Hart), 95–96
drawings
 asking for opinions on, 75–78
 conceptualizing, 68–69

Christopher Hart *has had over 100 books published, which have been translated into 20 languages and sold more than 8 million copies. Several of his titles have become #1 bestsellers in the art category, according to Bookscan. He has been featured on the cover of* Publisher's Weekly. *As a writer, Chris has worked for NBC, 20th Century Fox, MGM-Pathé, Showtime, and Paramount.*

Christopherhartbooks.com
Facebook.com/CARTOONS.MANGA
Youtube.com/user/chrishartbooks